Film Noir: A Very Short Introduction

VERY SHORT INTRODUCTIONS are for anyone wanting a stimulating and accessible way into a new subject. They are written by experts, and have been translated into more than 45 different languages.

The series began in 1995, and now covers a wide variety of topics in every discipline. The VSI library currently contains over 550 volumes—a Very Short Introduction to everything from Psychology and Philosophy of Science to American History and Relativity—and continues to grow in every subject area.

Very Short Introductions available now:

ABOLITIONISM Richard S. Newman
ACCOUNTING Christopher Nobes
ADAM SMITH Christopher J. Berry
ADOLESCENCE Peter K. Smith
ADVERTISING Winston Fletcher
AFRICAN AMERICAN RELIGION
 Eddie S. Glaude Jr
AFRICAN HISTORY John Parker and
 Richard Rathbone
AFRICAN POLITICS Ian Taylor
AFRICAN RELIGIONS
 Jacob K. Olupona
AGEING Nancy A. Pachana
AGNOSTICISM Robin Le Poidevin
AGRICULTURE Paul Brassley and
 Richard Soffe
ALEXANDER THE GREAT
 Hugh Bowden
ALGEBRA Peter M. Higgins
AMERICAN CULTURAL HISTORY
 Eric Avila
AMERICAN HISTORY Paul S. Boyer
AMERICAN IMMIGRATION
 David A. Gerber
AMERICAN LEGAL HISTORY
 G. Edward White
AMERICAN NAVAL HISTORY
 Craig L. Symonds
AMERICAN POLITICAL HISTORY
 Donald Critchlow
AMERICAN POLITICAL PARTIES
 AND ELECTIONS L. Sandy Maisel
AMERICAN POLITICS
 Richard M. Valelly

THE AMERICAN PRESIDENCY
 Charles O. Jones
THE AMERICAN REVOLUTION
 Robert J. Allison
AMERICAN SLAVERY
 Heather Andrea Williams
THE AMERICAN WEST Stephen Aron
AMERICAN WOMEN'S HISTORY
 Susan Ware
ANAESTHESIA Aidan O'Donnell
ANALYTIC PHILOSOPHY
 Michael Beaney
ANARCHISM Colin Ward
ANCIENT ASSYRIA Karen Radner
ANCIENT EGYPT Ian Shaw
ANCIENT EGYPTIAN ART AND
 ARCHITECTURE Christina Riggs
ANCIENT GREECE Paul Cartledge
THE ANCIENT NEAR EAST
 Amanda H. Podany
ANCIENT PHILOSOPHY Julia Annas
ANCIENT WARFARE
 Harry Sidebottom
ANGELS David Albert Jones
ANGLICANISM Mark Chapman
THE ANGLO-SAXON AGE John Blair
ANIMAL BEHAVIOUR
 Tristram D. Wyatt
THE ANIMAL KINGDOM
 Peter Holland
ANIMAL RIGHTS David DeGrazia
THE ANTARCTIC Klaus Dodds
ANTHROPOCENE Erle C. Ellis
ANTISEMITISM Steven Beller

WORK Stephen Fineman
WORLD MUSIC Philip Bohlman
THE WORLD TRADE
 ORGANIZATION Amrita Narlikar

WORLD WAR II Gerhard L. Weinberg
WRITING AND SCRIPT
 Andrew Robinson
ZIONISM Michael Stanislawski

Available soon:

CONCENTRATION CAMPS
 Dan Stone
READING Belinda Jack

MATTER Geoff Cottrell
HOMER Barbara Graziosi
SYNAESTHESIA Julia Simner

For more information visit our website

www.oup.com/vsi/

James Naremore

FILM NOIR

A Very Short Introduction

OXFORD
UNIVERSITY PRESS

OXFORD
UNIVERSITY PRESS

Great Clarendon Street, Oxford, OX2 6DP,
United Kingdom

Oxford University Press is a department of the University of Oxford.
It furthers the University's objective of excellence in research, scholarship,
and education by publishing worldwide. Oxford is a registered trade mark of
Oxford University Press in the UK and in certain other countries

© James Naremore 2019

The moral rights of the author have been asserted

First edition published in 2019

Published in the United States of America by Oxford University Press
198 Madison Avenue, New York, NY 10016, United States of America

British Library Cataloguing in Publication Data
Data available

Library of Congress Control Number: 2018957114

ISBN 978-0-19-879174-4

Printed and bound by
CPI Group (UK) Ltd, Croydon, CR0 4YY

Contents

Preface

Many people recognize a film noir when they see one—or so we might assume from the numerous retrospectives, DVD sets, and books that deal with the subject. But defining the term is notoriously difficult. It's usually associated with narrative, stylistic, and design qualities of black-and-white Hollywood pictures from the 1940s and 1950s: drifters attracted to sexy women, private eyes hired by femme fatales, criminal heists, corrupt police, young lovers on the run, flashbacks, offscreen narration, shadowy interiors, dark rainy streets, diners, swank nightclubs, snap-brim hats, cigarettes, hard liquor, snub-nose revolvers, and hard-boiled dialog. ("Is there any way to win?" Jane Greer asks Robert Mitchum in *Out of the Past* [1947]. "There's a way to lose more slowly," he replies.)

Such films occupy a fictional zone somewhere between Gothic horror and dystopian science fiction; as narrative formulas, they derive from what Jean-Paul Sartre called the literature of "extreme situations" and what Graham Greene called "blood melodrama"; and as commercial products, they blur the distinction between formulaic entertainment and art films. But critics disagree about whether they should be understood as a genre, a period, a movement, a series, a cycle, a style, or simply a "phenomenon." There is, moreover, no completely satisfactory way to organize the category. It contains private-detective thrillers (*The Maltese*

Falcon (1941)), "women's pictures" (*Possessed* (1947)), spy stories (*The Mask of Dimitrios* (1944)), costume adventures (*Reign of Terror* (1949)), westerns (*Pursued* (1947)), sleekly erotic love stories (*Gilda* (1946)), and realistic social satires (*Sweet Smell of Success* (1957)). Except for a degree of thematic or tonal darkness, nothing, not even crime, is shared by everything that has been called film noir.

The problems don't end there. Popular histories often say that film noir originated as a synthesis between American writers of "hard-boiled" or "tough" crime fiction and a group of German émigré directors in Hollywood who brought "Expressionism" to the studios. But if that's the case, why does noir have a French name, and why did the name not gain wide usage in America until the 1970s? (No Hollywood filmmakers or American reviewers of the 1940s and 1950s used "noir" to describe the films.) Popular histories also say that film noir began around 1941, with John Huston's adaptation of *The Maltese Falcon* (which had been adapted twice previously), and ended around 1958, with Orson Welles's *Touch of Evil*. But films were called noir in France during the 1930s, and filmmakers in Hollywood and around the world never stopped making pictures that are advertised as noir or can be described as noir. Today, self-conscious examples appear in movies and television from virtually every country in the world. A plausible case can indeed be made that the term film noir is mostly the creation of postmodern culture, a belated critical reading of classic Hollywood that exerted influence on late 20th-century and contemporary cinema.

In this volume, I argue that to make sense of the term one needs to recognize that it belongs both to the history of cinema and to the history of ideas; in other words, it concerns both a series of seductively entertaining movies and an evolving history of critical reception that names a category, shapes commercial strategies, and influences ways of seeing. This is the primary reason why film noir is difficult to define. It can refer to an amorphous set of films,

a dead period, and an ongoing tradition. It's both an important cinematic legacy and an idea we've projected onto the past.

Most of what I've just said is derived from what I argue in *More than Night: Film Noir in its Contexts* (rev. edn 2008), still in print, which gives readers a comprehensive view of the topic and greater discussion of representative films. Here, I revisit some of the issues in that book—the critical discourse that defines the films, the literary sources of classic film noirs, the censorship practices and politics that affected Hollywood noir, the low-budget qualities of many of the pictures (as Godard once said, all you need is a girl, a car, and a gun), and the distinctive styles they employ. Except in one instance in Chapter 5, I've avoided such terms as "neo noir" and "retro noir," which critics often use to designate pictures made after 1960. Elsewhere I prefer to distinguish between what I call "historical" or "classical" Hollywood noir and film noir in general, which is a much broader category. I've also not been reluctant to evaluate individual films. My aim is to combine film criticism and history, in the belief that arguments over value, even if you don't agree with them, have both aesthetic and political interest.

Acknowledgments

My thanks to Latha Menon and Jenny Nugee for editorial and production advice, to Geoffrey Nowell-Smith, who was a most helpful reader, and, as always, to Darlene J. Sadlier for everything.

List of illustrations

Chapter 1
The idea of film noir

We can never know what was the first film noir. There are many excellent pre-1941 candidates from America, Britain, and Europe, among them Joe May's *Asphalt* (Germany, 1928, concerning the relationship between a Berlin policeman and a sexy female thief); Anthony Asquith's *A Cottage on Dartmoor* (Britain, 1929, a silent thriller as good as anything Hitchcock did in the period); Fritz Lang's *M* (Germany, 1930, the dark chronicle of a search for a serial-killing pedophile); and Pierre Chenal's *Le Dernier Tournant* (France 1939, the first of six movie adaptations of James M. Cain's *The Postman Always Rings Twice*). If we want to continue expanding the amorphous category, we can find rough examples as far back as D. W. Griffith's *Musketeers of Pig Alley* (1912), which was arguably the first gangster film.

On the other hand, we can say with some accuracy when the term "film noir" was first applied to movies, and to which movies. It originates with French critics who used it during the 1930s to describe atmospheric French Popular-Front films about doomed low-life or working-class characters—pictures such as *Pépé le Moko* (1937; Figure 1), *Quai des brumes* (*Port of Shadows*, 1938) and *Le Jour se lève* (*Day Break*, 1939). The adjective "noir," which for right-wing French critics had negative implications, was associated with the *roman noir* (Gothic novel), and it took on other associations in 1946, when the prestigious publishing firm

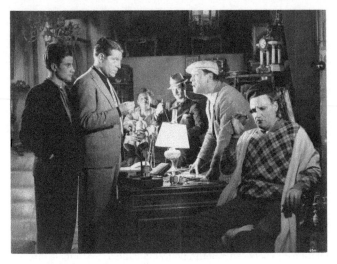

1. *Pépé le Moko* (France, 1936).

Gallimard began its *Série noire* (noir series) of black-and-yellow covered paperbacks, which were sometimes described as *littérature de la gare* (train-station literature). Many of them were translations of tough American crime writers, and they had international appeal. (As the Turkish Colonel Haki says in Eric Ambler's *A Coffin for Dimitrios*, "I get all the latest *romans policiers* sent to me from Paris. All the best of them are translated into French.")

Also in 1946, five Hollywood films, unavailable in France during the Occupation, appeared in quick succession on Paris movie screens: *The Maltese Falcon*, *Double Indemnity* (1944), *Murder, My Sweet* (1944; Figure 2), *Laura* (1944), and *The Lost Weekend* (1945). They were widely reviewed, with sidelong references to Welles's *Citizen Kane* (1941) and Hitchcock's *Suspicion* (1941). Two critics wrote film-journal essays about them. Nino Frank's "A New Genre of 'Police Story': The Criminal Adventure," published in the socialist *L'Écran français*, praised the Americans for

2

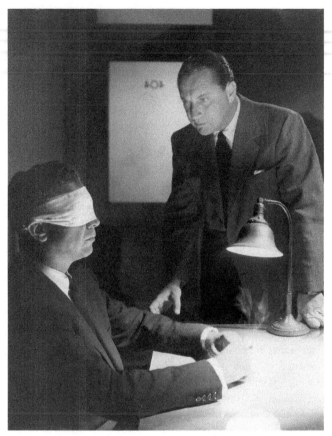

2. *Murder, My Sweet* (1944).

depicting the "social fantastic" and the "dynamism of violent death," and for innovating a series of true "*films noir*"—harsh and realistic films, prone to flashbacks or convoluted action, and centered on "criminal psychology." Jean-Pierre Chartier's "The Americans Also Make Film Noirs," published in the more conservative *Revue du cinéma*, was qualified in its assessment. Chartier admired *Murder, My Sweet*, which reminded him of

"the old avant-garde," but was concerned about the decadence and immorality of the Americans; the pre-war French film noirs, he argued, had "accents of rebellion, a fleeting glimpse of hope for a better world," but these new American films were dispassionate accounts of "monsters, criminals whose evils nothing can excuse."

In the United States, reviewers barely noticed a French antecedent for the films; many reviews of *The Maltese Falcon*, for example, compared John Huston with Alfred Hitchcock. But when roughly similar films appeared in subsequent years, the French continued to define them ostensively and normatively, pointing out dark films and compiling lists of them. Item A in the typical list shared some traits with B; B shared some traits with C; C shared other traits with D; and so forth, with the result that some items were different from others. In the short original list, for example, *The Lost Weekend* isn't a crime story and has relatively little in common with *The Maltese Falcon*.

By this means, France invented the concept of American film noir. It did so in part because it had a serious film culture of journals and "cine-clubs" that treated the medium as an art form rather than merely commercial entertainment. It was also experiencing a wave of Americanism that strengthened its interest in Hollywood. Having just emerged from *les années noires*—the dark days of the Occupation—its younger generation was especially attracted to smoky jazz clubs and the world-weary atmosphere of the typical Bogart thriller. Among intellectuals, this was the period of Existentialism, when American crime writers such as Dashiell Hammett and Raymond Chandler and pre-war novelists such as Ernest Hemingway, William Faulkner, and Richard Wright, who had also written about crime and violence, were considered existentialists *avant la lettre*. In *What is Literature?* (1947), Jean-Paul Sartre wrote, "As for the Americans, it was not their cruelty or pessimism which moved us. We recognized in them men who had been swamped, lost in too large a continent, as we were in history, and who tried, without traditions, with the means

available, to render their stupor and forlornness." The Catholic existentialist André Bazin, whose essays of 1958–62 were collected in *What is Cinema?*, wrote an elegy for Humphrey Bogart, arguing that "the *raison d'être* of [Bogart's] existence was in some sense to survive." Bogart was a man "*defined* by fate," and "the *noir* crime film whose ambiguous hero he was to epitomize" made him the quintessential "actor/myth of the postwar decade."

French existentialists were attracted to American film noir because it depicted a world of obsessive return, dark corners, or *huis-clos*—settings like the foggy seaside diner in *Fallen Angel* (1945), where Dana Andrews gets off a bus and seems unable to leave. ("I'm waiting for something to happen," he tells Alice Faye. "Nothing's going to happen," she replies.) They wrote a great deal about Southern Gothicism and tough-guy modernism, and were attracted to anything that offered what André Gide called "a foretaste of Hell." Gide declared that Dashiell Hammett's first novel, *Red Harvest*, was "the last word in atrocity, cynicism, and horror," and Albert Camus revealed that he was inspired to write *The Stranger* after reading Cain's *The Postman Always Rings Twice*. No wonder the existentialists, who often thought of film noir as a kind of proto-absurdism, were impressed with Robert Siodmack's *The Killers* (1946), adapted from a Hemingway story of the 1920s; the opening scene, in which a couple of murderous gunmen arrive at an all-night diner on the road to nowhere and complain about the menu, prefigures the darkness of such later writers as Samuel Beckett or Harold Pinter.

Surrealism and noir

It was not the existentialists, however, who had the strongest influence on French attitudes toward the new American films. That honor belongs to the Surrealists, who were a residual force in French culture and crucial to the reception of any art described as "noir." (See, for example, André Breton's 1940 *Anthologie d'humour noir* (*Anthology of Black Humor*).)

From their beginnings, the Surrealists had been movie fans, using cinema as an instrument for the desublimation of everyday life. André Breton and his associates would pop in and out of theaters, developing what Louis Aragon called a "synthetic" style of viewing devoted to the fetishistic qualities of individual shots or scenes. At certain moments, even the lowest grade-B productions could throw off bizarre images, strange juxtapositions, and erotic plays of light and shadow, allowing viewers to break free of plot conventions and indulge in private pleasures. Some films were especially conducive to such uses: Louis Feuillade's *Fantômas* and *Les Vampires* (France, 1913–16); Buster Keaton's crazy comedies; *The Most Dangerous Game* (1932); *King Kong* (1933); and, in the 1940s, Chandleresque detective pictures, which, especially in the case of *The Big Sleep* (1946), lost control of their plots and became hallucinatory adventures in the criminal underworld.

As early as 1918, Aragon had written that Hollywood gangster pictures "speak of daily life and manage to raise to a dramatic level a banknote on which our attention is riveted, a table with a revolver on it, a bottle that on occasion becomes a weapon, a handkerchief that reveals a crime, a typewriter that's the horizon of a desk." He might as well have been describing crime films of the 1940s and 1950s, many of which were confined to interiors and shot in a deep-focus style that seemed to reveal the secret life of things. For the Surrealists, such films also had other attractions: they often told stories about *amour fou*, they had Sadean titles like *Murder, My Sweet* and *Kiss Me Deadly* (1955), and they tended to be derived from a mildly hallucinated literature of drugs and alcohol. Huston's version of *The Maltese Falcon* counted several ways, not least because it centered on a fetishistic object—a black bird, which Sam Spade called "the stuff that dreams are made of."

Eventually, an extensive list of noir films was compiled by two Surrealist cinephiles, Raymond Borde and Étienne Chaumeton, in the first and most important book on the subject: *A Panorama of the American Film Noir: 1941–1953*, first published in 1955 in

France and given an English translation in 2002. This book's impact on the world of film was not unlike that of Charles Baudelaire's 19th-century translations and essays about Edgar Allan Poe on the literary world. It gave identity and cachet to pictures that might have been forgotten, and in the process helped to create what today's movie industry regards as a fully-fledged genre. Few works of criticism in any field have had such a seminal effect on both scholars and artists.

Borde and Chaumeton were based in Toulouse; Chaumeton was a film critic for the newspaper *La Dépêche*, and Borde, who was a founder of the local cinematheque, became a social critic and novelist who made two films—a short about Surrealist artist Pierre Molinier, and, in conjunction with Robert Benayoun and Jacques Brunius, an incomplete documentary entitled *Le Surréalisme* (1964). The two men were intelligent, discerning viewers who were contemporary with the films they discussed, and the first two editions of their book were written in direct response to a series of tough or "hard-boiled" thrillers and bloody melodramas Hollywood had been producing regularly for about fifteen years, beginning with John Huston's *The Maltese Falcon* and culminating with Robert Aldrich's jagged, apocalyptic *Kiss Me Deadly*. They recognized that the French had made noir films in the 1930s (one chapter of their book is devoted to French cinema), but they centered their attention on Hollywood, treating its pictures as expressions of the quotidian violence and criminality of American life and as critiques of American capitalism.

Marcel Duhamel, the founding editor of Gallimard's *Série noire* and a member of the original Surrealist Group (he assisted in the 1925 development of the "Exquisite Corpse" game and in the 1930s participated in the Surrealist *recherches* into sexuality), contributed a witty introduction to the first edition of the *Panorama*, in which he recalls the period 1923–6, when he and other Surrealists, "like faithful followers of a magic rite," watched "miles" of Hollywood movies "solely of the noir kind. Loads of

William Wellman, notably." If this were not enough to connect the *Panorama* to the history of Surrealism, Borde and Chaumeton make the relationship explicit by choosing a phrase from Lautréamont, the Surrealists' favorite poet, as an epigraph for their book: "The bloody channels through which one pushes logic to its breaking point."

In their opening chapter, Borde and Chaumeton describe the 1940s and 1950s films they are discussing as a "cycle" or "series" characteristic of a period and analogous to the tough paperbacks published by Gallimard. They define noir not in terms of subject matter or style but in terms of five affective qualities typical of Surrealist art: "oneiric, strange, erotic, ambivalent, and cruel." The second of these adjectives, "*insolite*" in French, is the most important and most difficult to translate. English translator Paul Hammond prefers "strange," which I've adopted. "Bizarre" or "Kafkaesque" are also possibilities, and as Hammond points out the word also has something in common with Freud's "uncanny," the Russian Formalists' "defamiliarization," and Brecht's "alienation effect."

How many of the five qualities does a film need to be called noir? Borde and Chaumeton don't say, and they try to evade the problem by announcing that they're concerned with "productions that critics have most often deemed to be 'film noirs.'" This is as good a solution as any. Film theorist Peter Wollen once remarked to me, not altogether facetiously, that the best way to define a film noir is to say that it's any movie listed by Borde and Chaumeton. In fact, most cultural categories are formed not by establishing necessary and sufficient characteristics for membership, but by a process of association that creates networks of relationship; and in any such category, some members will be different from others. The five major representatives of "English Romantic poetry," for instance, are Wordsworth, Coleridge, Byron, Shelley, and Keats; but Byron is different in significant ways from the others.

8

Notice also that despite attempts by historians to create taxonomies, narratives often have a hybrid quality: there are musical westerns, sci-fi westerns, comic westerns, and noir westerns. For Borde and Chaumeton, film noir is made up of a central core of films that have been dubbed noir by other critics, plus an array of crime films, period films, psychological melodramas, and even cartoons that are related to members of the central core. A great many later writers on the subject have followed a similar procedure, so that film noir has become what French critic Marc Vernet calls a "collector's cinema," one of the charms of which is that "there is always an unknown film to be added to the list."

At other places in *Panorama*, however, Borde and Chaumeton make film noir less like a loosely connected series than like an anti-genre that systematically rebels against Hollywood conventions. They point out that film noir is sometimes told from the point of view of criminals who elicit our sympathy. Even when the central character is nominally on the right side of the law, he or she is often a corrupt cop, a morally ambiguous private eye, or a fugitive wrongly accused of crime. (Nevertheless, many films they and others describe as noir, such as *Naked City* (1948) and *Union Station* (1950), are police procedurals, counted as noir by virtue of their toughness and shadowy urban settings.) At almost every level, Borde and Chaumeton argue, film noir inverts formulas. In place of straightforward narratives with clearly motivated characters, it offers flashbacks populated by ambiguous figures. In place of stalwart heroes, it gives us "not particularly handsome" leading men who, before the obligatory happy ending, suffer "appalling beatings." In place of virginal or domesticated heroines, it presents us with femme fatales, the modern-day descendants of Sade's Juliette, who contribute to an "eroticization of violence." (The ideal leading man for Borde and Chaumeton was Humphrey Bogart, and the ideal leading woman was Gloria Grahame—who, although she never played a femme fatale, conveyed a vixen-like toughness. The only time they appeared together was in Nicholas Ray's *In a Lonely Place* (1950; Figure 3).)

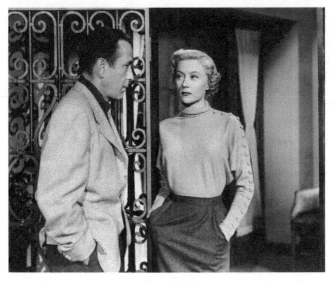

3. Gloria Grahame and Humphrey Bogart in *In a Lonely Place* (1950).

Borde and Chaumeton are especially intrigued by the violence in American film noir, which replaces Hollywood's chivalric sword fights and melodramatic gun duels with a "ceremony of killing" that has sadomasochistic overtones. American director Anthony Mann was especially adept at these scenes, as in *T-Men* (1947) and *Border Incident* (1949), but there are plenty of examples by others. In *The Killers*, Burt Lancaster dies under a fusillade of bullets as he lies in bed mourning the loss of Ava Gardner, who has used and deserted him. In *The Set-Up* (1949), small-time boxer Robert Ryan is cornered in an alley by gangsters and beaten to death for refusing to throw a fight. In *The Glass Key* (1942), William Bendix pounds Alan Ladd's face into hamburger while calling him "sweetheart." In *The Dark Corner* (1946), Bendix (again) steps on the unconscious Mark Stevens's thumb and crushes it. In *Kiss of Death* (1947), Richard Widmark giggles with delight as he pushes a little old lady in a wheelchair down a flight of stairs. In *The Big Heat* (1953), two characters are burned in the face with boiling

coffee: Gloria Grahame is first, and the audience recoils in horror; Lee Marvin, who burned Grahame, is second, and the audience usually cheers.

This "incoherent brutality," Borde and Chaumeton write, creates something "dreamlike." But the oneiric effect isn't limited to scenes of violence. Consider two Fritz Lang films with virtually the same cast: *Woman in the Window* (1944), which makes the dream of a repressed professor of psychology seem real; and its mirror image, *Scarlet Street* (1945), which gives the waking life of a bank clerk and Sunday painter the quality of a Brechtian, blackly comic nightmare. An especially elaborate use of dream can be seen in Arthur Ripley's *The Chase* (1946), a film so strange that sleep and waking life are indistinguishable. Notice also the frequent use of surrealistic dream sequences in noir, as in *Murder, My Sweet* and *Spellbound* (1945)—a tradition continued in such later films as *Seconds* (1966) and the comic pastiche *The Big Lebowski* (1998). Still other pictures take place at the margins of dreams, most notably *Laura*, in which a detective who is romantically obsessed with a beautiful dead woman takes a drink of whiskey, falls asleep in an armchair, and awakes to find the woman standing before him.

In listing productions they think most impressively oneiric, strange, cruel, etc., Borde and Chaumeton are sometimes unorthodox. When they name the pictures that inaugurated the noir "style" between 1941 and 1945, they include Josef von Sternberg's *The Shanghai Gesture* (1941), which resembles Sternberg's films with Marlene Dietrich in the 1930s. (This film was a favorite of the Surrealists, who used it for a game or "experiment" involving the "irrational enlargement" of a film scene, first published in 1951.) They also place *Double Indemnity* outside the central core of the series and have little to say about *Out of the Past*, which most people today think of as a definitive noir. Nevertheless, they're good at showing how other kinds of films were "noirified," among them the Victorian-age melodramas

Gaslight (1944) and *The Spiral Staircase* (1946), the tough western *Ramrod* (1947), and Orson Welles's *Macbeth* (1948).

"Film noir is *for us*," Borde and Chaumeton say, by which they mean "for Western and American audiences of the 1950s." But they also argue that the noir series is nearing its end. At the beginning of the decade, important examples appeared: John Huston's *The Asphalt Jungle* (1950), which set the standard for the heist film; Joseph H. Lewis's *Gun Crazy* (1950), which Borde and Chaumeton consider the "*L'Age d'or* of American film noir"; and Alfred Hitchcock's *Strangers on a Train* (1951), which they describe as a "cocktail" of black humor and suspense. Even so, the private-detective myth was growing stale, the strange was becoming familiar, and a season in hell was beginning to look like the snows of yesteryear. At a revival of *Murder, My Sweet* for the Toulouse cine-club in 1953, the audience laughed when Philip Marlowe was repeatedly knocked out and descended into a black pool. That same year, television and the growing leisure industry led Hollywood to produce wide-screen, stereophonic epics, and the rise of McCarthyism led to the blacklisting of several key writers and directors of film noir.

An apparent coup de grace was administered by two films, both prompted by the craze for right-wing novelist Mickey Spillane, who in the early 1950s achieved unprecedented success in the American paperback market. In MGM's *The Band Wagon* (1953), director Vincente Minnelli, whom Borde and Chaumeton describe as "the most refined man in Hollywood," staged a balletic parody of both Spillane and classic film noir, its design inspired by "a facile and banalized Surrealism." The result was "a final concession to our past," in which the formulaic essence of the noir series was grasped in "lucid complicity." Not long afterward came Robert Aldrich's ideologically ambivalent, jaw-dropping adaptation of Spillane's *Kiss Me Deadly* (Figure 4)—a film which, in the Postface to the 1979 edition of *Panorama*, Borde and Chaumeton describe as the despairing opposite of *The Maltese Falcon*: "Between 1941

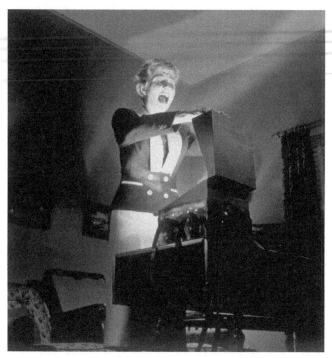

4. *Kiss Me Deadly* (1955).

and 1955, between the eve of war and the advent of consumer society, the tone has changed. A savage lyricism hurls us into a world in manifest decomposition... Aldrich offers the most radical of solutions: nuclear apocalypse."

Noir everywhere

But claims of the death of film noir, like those involving God and the novel, were premature. In a postscript to the 1988 edition of the *Panorama*, Borde and Chaumeton note the "fascinating renaissance" of such films, adding to their list *Dr. No* (1962), *Point Blank* (1967), *Dirty Harry* (1971), *Badlands* (1973), and *Soylent*

Green (1973). "Historical" American film noir, a product of the classic studio system, was indeed at an end, along with its mode of production. Many of the 1940s and 1950s films, however, have been preserved and remain the beating heart of dark cinema, giving viewers as much pleasure as ever. The musical and the western, once regarded as quintessentially American, also survive and are equally pleasurable, but no longer play a central role in popular culture. By contrast, film noirs, which were never exclusive to America, continue to appear from Hollywood and elsewhere.

In the 1960s and 1970s, European art films and the worldwide growth of cinephilia prompted intense, often nostalgic interest in noir. Old film noirs were being shown regularly in big-city retrospectives and college film societies, and were becoming a staple of late shows on TV. Two of the most successful films of the French nouvelle vague, Godard's *Breathless* (1960) and Truffaut's *Shoot the Piano Player* (1960), paid homage to American noir. In 1968, critic Andrew Sarris published *American Cinema: Directors and Directions*, importing to America what he called the French "auteur theory" and further prompting interest in the classic films.

In 1970, British critic Raymond Durgnat published "Paint It Black: The Family Tree of Film Noir," which transmitted French Surrealist values to an English-speaking readership. Like Borde and Chaumeton, Durgnat concentrated on 1940s and 1950s Hollywood and identified noir with love on the run, fatal passion, sexual pathology, and so on. But he emphasized that noir has no political, historical, or national boundaries; its characteristic motifs and tones, he argues, are "perennial," as old as *Oedipus Rex*, and can be explained in roughly Freudian terms as responses to guilt, crime, and punishment. Four years later, when he published the essay in America, he accompanied it with a faux-scientific chart that created an irrational expansion; besides the usual suspects, his family tree included *Jezebel* (1938), *Monsieur Verdoux* (1947), *The Treasure of the Sierra Madre* (1947), *Portrait of Jennie* (1948), *Shadows* (1960), and *2001* (1968).

An American New Wave began to appear at roughly this time, and several of its young auteurs, aware of French criticism, made films that were noir-like in one way or another: see Peter Bogdanovich's *Targets* (1968), Brian de Palma's *Sisters* (1973), and Martin Scorsese's *Mean Streets* (1973). The figure who most determined American ideas about noir, however, was the screenwriter and soon-to be director Paul Schrader, whose "Notes on Film Noir," written for a Los Angeles museum retrospective and published in a 1972 issue of *Film Comment*, openly acknowledged indebtedness to Borde and Chaumeton. Schrader describes noir as a cycle, although he also speaks of it as a "period" and a "movement," which he dates 1941–58: *The Maltese Falcon* begins it, *Kiss Me Deadly* provides its last masterpiece, and *Touch of Evil* serves as its "epitaph." But he adds Raymond Durgnat's idea that noir is a perennial set of moods, tones, and motifs, always available for renewal. More an existentialist than a Surrealist, Schrader stresses what he regards as a German-Expressionist visual style in American noir, calling attention to the brilliant photographer John Alton, who contributed to Anthony Mann's best crime films. He also correctly points out that "film noir was good for practically every director's career." (In the 1990s, Dennis Hopper said that film noir had become "every director's favorite genre.")

Schrader never mentions the Vietnam war, which was contemporaneous with his essay, but he predicts that where cinema is concerned, "as the current political mood hardens,...[t]he Forties may be to the Seventies what the Thirties were to the Sixties." The mood of the late 1940s, he says, led artists to expose "the underside of the American character." The chief value of film noir, he argues, is that in the period between 1941 and 1958, "Hollywood lighting grew darker, characters more corrupt, themes more fatalistic, and the tone more hopeless." Noir's heroes, he concludes, "try to survive by the day, and if unsuccessful at that, they retreat into the past"; and noir's techniques "emphasize loss, nostalgia, lack of clear priorities,...then submerge these doubts into mannerism and style."

Whatever the American mood of the 1940s was, these are approximately the values Schrader expressed in his screenplay for Martin Scorsese's *Taxi Driver* (1976). The Catholic Scorsese and the Calvinist Schrader created a bloody, mannerist film about a gun-crazy, sexually disturbed Vietnam veteran, and they gave city streets the feeling of a Dostoevskian night of the soul. The 1970s and 1980s were also a period when major Hollywood productions were made with an idea of film noir in mind, among them Robert Altman's *The Long Goodbye* (1973), Roman Polanski's *Chinatown* (1974), and Laurence Kasdan's *Body Heat* (1981). At the same time, an older generation of directors who had made noir pictures in the classic period returned to make new films of the type, such as Don Siegel's *Charley Varrick* (1973) and Robert Aldrich's *Hustle* (1975). At this point, noir was a recognized category of filmmaking, a brand the entertainment industry could exploit in a variety of ways.

From the 1970s until recently, in part because of Durgnat's and Schrader's influence, critical writing about film noir has tended to suggest that it's distinctly American. But countries around the world have made such films and will continue making them. Among the best from Latin America are Julio Bracho's *Distinto Amanecer* (Mexico, 1943), Fernando Ayala's *Los Tallos Amargos* (Argentina, 1957), Jorge Ileli's *Mulheres e Milhoes* (Brazil, 1961), Walter Salles's *Foreign Land* (Brazil and Portugal, 1995), and Fabian Belinsky's *Nine Queens* (Argentina, 2000). A few of the many Japanese film noirs, covering only the period from the 1940s to the 1960s, are Akira Kurosawa's *Drunken Angel* (1948), and *Stray Dog* (1949); Koreyoshi Kurahara's *I Am Waiting* (1957); Masaki Kobayashi's *Black River* (1957); and Seijun Suzuki's *Tokyo Drifter* (1966). Historian Robin Buss has listed 101 French film noirs produced between 1942 and 1993—a list that could be greatly expanded, starting with Jean Renoir's *La Nuit du carrefour* (1932) and leading to recent examples such as Joann Sfar's *The Lady in the Car with Glasses and a Gun* (2015). Norwegian

scholar Audun Englestad has shown that Norway has produced many such pictures, beginning as early as 1937 and resulting in such impressive films as Erik Skjoldbjærg's *Insomnia* (1997), which uses the uncanny evening light of a Nordic summer to create a twist on the usual noir atmosphere. More recently on European television, noir has proliferated. *The Killing* (Sweden, 2007–12) and *The Bridge* (Denmark, 2013–18) are often described as "Scandi-noir." *Clan* (Belgium, 2012) and *The Adulterer* (Netherlands, 2018) are equally dark. Similar lists could be constructed for Britain, Italy, Germany, Spain, and virtually every developed country in the modern world, no doubt because crime cinema is perennial, ubiquitous, and relatively inexpensive.

Any comprehensive history of noir would need to consider the international scope of the form, plus changes in technology, censorship, and modes of production since the 1950s; it would need to account for the dissolution of boundaries between high, vernacular, and commercial art, and for things besides Hollywood or even films. Today, forms of noir spread across every national boundary except those of very poor, highly authoritarian, or religious-fundamentalist states. In the world of global capitalism, noir has become not simply a cycle or a genre but a brand name that can be applied to crime fiction of various nationalities ("Nordic noir," "Tartan noir"), video games (*Max Payne, L.A. Noire*), television series (*Breaking Bad, Bosch*), and consumer goods (*Victoria's Secret Perfume Noir*).

Why has noir become so pervasive? I would argue that a noir sensibility has been characteristic of modernity since the end of World War I—a pessimistic, romantic, sometimes critical, usually "cool" attitude about crime and the darker realms of sex and violence, which provides both commercial and artistic opportunities for the media industries. A more interesting question is whether a category of films developed by French critics before and after World War II functions in the same way for us.

If we were to ask the original French commentators what American film noir represented, they would probably agree that it was a kind of critical modernism in the cinema: it used unorthodox narration, it resisted sentiment and censorship, it was drawn to the "social fantastic," it demonstrated the ambiguity of human motives, it sympathized with outsider characters, and it made the emerging commodity culture seem a wasteland. We shall have to decide what it represents today.

Chapter 2
The modernist crime novel and Hollywood noir

In 1955, looking back at the dark Hollywood films of the 1940s and 1950s, French critic and eventual filmmaker Erich Rohmer wrote, "Our immediate predilection tends to be for faces marked with the brand of vice and the neon lights of bars rather than the ones which glow with wholesome sentiments and prairie air." The best of such films, he argued, owed their inspiration to "the thriller genre" in American literature—crime novels whose charm lay in "the delirious romanticism of their heroes and the modernism of their technique. Hollywood, shy of them for so long, suddenly noticed their existence, and the breath of the avant-garde made the studios tremble. What came of it? There is now enough distance for us to judge: the answer is very little, if anything."

Whether or not anything came of it, Rohmer was correct to point to an atmosphere of "modernism" in American film noir, largely owing to the "thriller genre" in literature. (All five of the pictures French writers in 1946 labeled American film noir were literary adaptations, and four of them were thrillers.) To make the point clear, let me offer a few generalizations about modernism, an art term different from "modern" or "modernity" (which usually refer to industrial, technical, and social progress), and even more difficult to define than film noir.

None of the major figures associated with artistic modernism—Joyce, Picasso, Stravinsky, etc.—ever called themselves modernists. Like "film noir," modernism was labeled after the fact, largely by critics and historians; one of the first uses of the term is in a 1927 poetry anthology by Robert Graves and Laura Riding, but it didn't become commonplace until mid-century. In any case, most forms of what came to be known as modernist art could be seen by 1914 in New York and the European capitals when World War I was beginning to shatter the previous century's established institutions. A cosmopolitan, trans-continental movement generated by the second industrial revolution, it was frequently about such things as metro stations, cinemas, jazz, and the spaces of urban modernity. In some of its elite manifestations, however, as in T. S. Eliot's *The Waste Land* or Theodor Adorno's later analysis of the "dark Enlightenment," it was deeply critical of instrumental reason, industrial modernity, and liberal democracy. As economic power shifted westward, the leading modern writers in Europe, whether right wing or left wing, were ambivalent about the United States, which seemed both a dynamic force of modernity and a threat to cultural values. In Weimar Germany, a complex discourse on America persisted throughout the 1920s, and in the same period a "lost generation" of American writers took advantage of exchange rates, moving to Paris, where Gertrude Stein, Ernest Hemingway, Scott Fitzgerald, and many others lived as expatriates.

Many of modernism's artistic products were aestheticized and self-reflexive, but modernism in all its forms was at least implicitly an attack on Europe's bourgeois values and provincial America's fundamentalism and Babbittry. In this regard, the modernist novel took a psychological turn. Prior to World War I, Henry James, Joseph Conrad, and Marcel Proust had made point of view and subjective temporality the hallmark of advanced narrative technique, and after the war James Joyce and Virginia Woolf employed stream of consciousness and other devices to suggest deep levels of the psyche. The modern novel also mounted an

implicit critique of industrial modernity's idea of progressive time. In David Lodge's words, it "eschews the straight chronological ordering of the material, and the use of a reliable, omniscient and intrusive narrator. It employs, instead, either a single, limited point of view or multiple viewpoints, all more or less limited and fallible; and it tends toward a complex or fluid handling of time, involving much cross-reference back and forward across the temporal span of the action."

The emancipation of women had brought female sexuality to the fore, but at the same time several of the male modernists created a gendered opposition to middle-class culture, which they described as ladylike. Poets derided the flowery rhetoric of the Victorians and advocated what Ezra Pound called "hard" and "clear" imagery. Writers of prose, from journalists to novelists, became plainspoken and "masculine." The time was ripe for tough-guy stylists like Hemingway and Louis Ferdinand Céline. Elsewhere, especially in the films of Weimar Germany, females were treated as sexy but dangerous embodiments of modernity itself: prime examples include Brigitte Helm as the "false Maria" in Lang's *Metropolis* (1927) and the American Louise Brooks as Lulu in G. W. Pabst's *Pandora's Box* (1929).

All these currents—the interest in subjectivity and multiple points of view, the unorthodox handling of time, the stripping away of genteel rhetoric, the critique of modernity, the mixture of explicit sex and fears of women—came together in representations of the Dark City, a topos as old as William Blake, which was transformed into the mise-en-scène of the male unconscious (as in the Nighttown chapter of Joyce's *Ulysses*), or into the shadowy vision of a seductive, American-style metropolis, filled with blind alleys.

For French viewers of American film noirs in the 1940s, it was obvious that Hollywood was influenced by themes and formal devices associated with inter-war modernism. (The French film critics were themselves modernists; Nino Frank, one of the first

writers about Hollywood noir, knew Joyce and helped translate Joyce's "Anna Livia Plurabelle" into Italian.) Movie thrillers of the period had metropolitan cityscapes, subjective narration, non-linear plots, tough language, and misogynistic eroticism; they also had a critical or at least realistic attitude toward the America of the fast buck. This wasn't surprising, because in the previous two decades modernism had influenced melodramatic fiction of all kinds, and writers and artists with serious aspirations now worked at least part time for the movies.

When the trend reached a peak in the early 1940s, it made traditional formulas, especially the crime film, seem more "artful." There was a vogue for flashbacks, the most elaborate example being *The Locket* (1946), which creates a subjective mise-en-abyme; and for psychoanalysis, not only in *The Locket* but also in such pictures as *Spellbound* (1945), *Possessed*, and, in more unorthodox form, *Nightmare Alley* (1947), in which the psychoanalyst is no different from a fake spiritualist. Narratives and camera angles were organized along subjective lines, characters were depicted in shades of gray, urban women became eroticized and dangerous, endings were less unproblematically happy, and violence looked more pathological.

This development in film was prompted in part by modernist crime literature during the 1920s and 1930s, which had rebelled against the popular whodunit. We should remember that the literary fascination with murder is at least as old as the ancient Greeks or the Elizabethan/Jacobean "tragedy of blood" of Thomas Kyd and John Webster (Webster's *The Duchess of Malfi* would make a good film noir), and that major literary figures of the late 19th and early 20th century had been interested in dark crime narratives: Henry James, for example, experimented with the spy novel, and Joseph Conrad, who specialized in "secret sharers," told a French colleague that society itself was a criminal conspiracy: "Crime is a necessary condition for all kinds of organizations. Society is essentially criminal—or it would not exist." Even so, in

the 19th century Edgar Allan Poe and Conan Doyle had created a type of detective fiction that subordinates bloody action to the solution to a puzzle. The plots of such fiction always have a "what-will-have happened" or future-perfect form: a murder is discovered, but the story behind the crime isn't revealed until the last chapter, by a clever investigator who has never been in personal danger. This form dominated the popular marketplace, and when viewed from a modernist perspective, the hugely successful whodunits of Agatha Christie and Dorothy L. Sayers appeared snobbish and supportive of the British establishment.

In his post-World War II essay "The Guilty Vicarage," modernist poet W. H. Auden nevertheless confessed to a fondness for the Christie-style whodunit, especially when set in Edenic "rural England," where somebody is murdered, and a detective is called in to question the suspects. Auden described such novels as an unconscious form of Christian allegory: by solving the puzzle of the crime, he observed, the detective expunges sin and restores the British village or country house to their pastoral, Edenic condition. In contrast, Auden wrote, the American novels of Raymond Chandler were serious studies of a criminal milieu, set not in Eden but in "the Great Bad Place."

The "Bad Place" form had emerged with the growth of sensationalized pulp magazines aimed at an audience of men, and was enhanced by an increasing appetite on the part of respectable publishing companies for what were called "hard-boiled" thrillers—tough novels that subordinated their mystery element to action and the description of a milieu. Through these venues, literary modernism interacted with mass culture and made its way to movies.

Hollywood was of course already aware of vanguard developments in modern art. The most obvious sign of "artistic-ness" in American cinema during the inter-war years was a somewhat Germanic or expressionist style, as in F. W. Murnau's *Sunrise*

(1927), King Vidor's *The Crowd* (1928), and Orson Welles's *Citizen Kane*. In the same period, there was a tradition of vernacular or popular modernism, as in Buster Keaton's films or in Busby Berkeley's "The Lullaby of Broadway" dance number in *Golddiggers of 1935*. In the 1930s, Hollywood also began to show an interest in tough crime, in part because of the success of the Warner Bros gangster cycle and Howard Hawks's *Scarface* (1932). Of the four American thrillers initially dubbed noir by the French, two were remakes of low-budget Hollywood productions from the 1930s based on novels by Dashiell Hammett and Raymond Chandler. The 1940s films, however, were expensively mounted, with sophisticated screenplays, talented directors, and shadowy lighting reminiscent of pre-war France and Weimar Germany; unlike the earlier pictures, they attracted critical attention and competed for Academy Awards.

By 1940, the high-modernist leopards who had disrupted the temple of culture were fully absorbed into the worship ceremony, and traces of modernist art were increasingly accepted into middle-class life. Thus, in a 1944 commentary on James Hadley Chase's best-selling noir novel *No Orchids for Miss Blandish*, George Orwell grumbled, "Freud and Machiavelli have reached the outer suburbs." And yet there was a tension or contradiction within the Hollywood film noirs of the 1940s. Certain attributes of modernism—its links to high culture, its formal and moral complexity, its frankness about sex, its criticism of American modernity—were a potential threat to the entertainment industry and were never fully absorbed into the mainstream. The tension was evident in Hollywood adaptations of four influential crime writers who were major contributors to the film noir but whose work needed to be lightened or ameliorated.

Hammett

Samuel Dashiell Hammett (1894–1961), the earliest and most politically radical of the popular-crime modernists, looked like an

aristocrat but was a former Pinkerton detective. He wrote innovative fiction for the pulps, rose to fame as a novelist for Alfred A. Knopf, and was considered a major prose stylist by no less an authority than Gertrude Stein. He was also at various points an advertising man, a Hollywood hack, a drinking partner of Willian Faulkner, a writer for a comic strip, and a committed Marxist who went to prison for his politics.

The type of detective story Hammett pioneered was printed on cheap paper in magazines with lurid covers depicting half-dressed women and armed men. His earliest stories and serialized novels, which appeared in *Black Mask*, the leading journal in the field, have non-stop action and as many dead bodies as an Elizabethan tragedy. But Hammett also had literary aspirations and political convictions; the only difference between him and an acknowledged modernist like Hemingway is that he expressed an emerging sensibility in popular adventure stories, attacking bourgeois values from "below." His success motivated him to submit the first of his serialized pulp novels to Blanche Knopf, one of the most astute editors in New York, who had imported European modernism to America and guided the careers of William Faulkner and Willa Cather. Hammett told Knopf that he wanted someday to experiment with stream of consciousness, and he agreed when she advised him to cut two dynamitings and a tommy-gun attack from his book. For the next decade, she gave an imprimatur to hard-boiled writing by him, James M. Cain, and Raymond Chandler.

Hammett's first novel, *Red Harvest* (1929), describes Hobbesian chaos in a town named "Personville" during the era of Prohibition-style gangsterism, open police violence, and murderous union-busting. The protagonist is a fat, fortyish operative for the Continental Detective Agency, identified only as "the Continental Op," who encounters enough murder to make him feel "blood simple" (the Coen brothers used those words as a title of a 1984 film noir). When a Personville capitalist hires him "to clean up this pigsty…and to smoke out the rats, little and big," he replies,

"what's the use of getting poetic about it? If you've got a fairly honest piece of work to be done in my line, and you want to pay a decent price, maybe I'll take it on."

The Op's laconic, less-deceived voice is typical of Hammett's tough detectives, who aren't completely virtuous and can't be taken in by appeals to morality or even love. In *The Maltese Falcon* (1930), when Brigid O'Shaunnessy tells Sam Spade that he can't turn her over to the police because he loves her, he says, "But I don't know what that amounts to. Does anyone ever?...Maybe next month I won't...Then I'll think I played the sap." In *The Glass Key* (1931), the suave gambler-detective Ned Beaumont, who is the friend and employee of a crude political boss, tells a young woman, "I don't believe in anything."

Hollywood optioned all of Hammett's novels, but was slow to give his work intelligent treatment. The studios never filmed *Red Harvest*, no doubt because of its raw violence, but the book eventually provided the basis for Akira Kurosawa's samurai picture *Yojimbo* (Japan, 1961). Sergio Leone virtually plagiarized Kurosawa's plot for the spaghetti western *A Fistful of Dollars* (Italy, 1964), which in turn influenced Walter Hill's *Last Man Standing* (1966). The only attempt at a straight movie adaptation of *Red Harvest* was a 1982 screenplay by Bernardo Bertolucci and Marilyn Golden, which didn't find a producer.

Warner Bros filmed *The Maltese Falcon* twice—a faithful but wooden version in 1931, and a lame semi-comedy entitled *Satan Met a Lady* in 1935. Also in 1935, Paramount filmed *The Glass Key*, avoiding the novel's realistic depiction of political corruption. The only excellent adaptation of Hammett during the period was MGM's *The Thin Man* (1934, the same year as the novel), a major hit that gave a comic turn to Hammett's relatively deadpan style, spawned sequels, and created a cycle of increasingly domesticated husband-and-wife detective pictures known in the industry as

"screwball crime." Graced with the sexual chemistry of William Powell and Myrna Loy, the photography of James Wong Howe, and the witty screenplay of Albert Hackett and Francis Goodrich, the adaptation was nevertheless lighter and less subversive than the novel. Hammett had reverted to the traditional whodunit form, in which the detective gathers suspects in a room and reveals a murderer, but his book is saturated with alcohol and its leading metaphor is cannibalism. The hard-drinking Nick Charles barely represses his feelings of being a kept man. During a wild party in his and Nora's posh apartment, he encounters a drunken fellow who tells him, "Comes the revolution we'll all be lined up against the wall—first thing." At the end, when he tries to explain the solution to the crime to Nora, she's skeptical. "This is just a theory, isn't it?" she asks. He says he's only trying to explain what's probable. "It's all pretty unsatisfactory," she complains.

Those were the last words Hammett wrote as a published novelist. Hollywood hired him as a screenwriter, but he spent money lavishly and began to drink as if, in the words of writer-director Nunnally Johnson, "he had no expectation of being alive beyond Thursday." In later life, he served in World War II, became active in left politics, quit drinking, refused to give names of communists to congressional investigators, and was persecuted by J. Edgar Hoover's FBI. His reputation endured, however, in part because *The Maltese Falcon* had become a classic, widely translated and republished in a Modern Library edition. From the beginning, American critics (among them Edmund Wilson, America's leading judge of literary modernism) had praised *Falcon* because it reversed the values of the ordinary detective story, making the whodunit less important than the realistic depiction of a criminal world. Who cares who killed Miles Archer? Spade knows at the start who the killer was, but withholds the information until the end, in a speech that mocks the idea of a just solution to murder, just as the search for the Falcon has mocked the idea of private property.

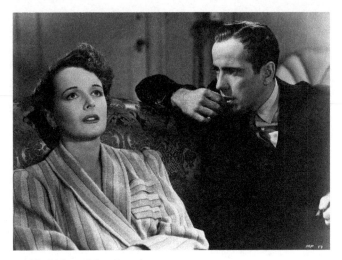

5. *The Maltese Falcon* (1941).

In 1941, when John Huston chose to remake *Falcon* (Figure 5) for his debut as a director, Hollywood finally produced a film worthy of the novel, prompting Paramount's tough remake of *The Glass Key* (1942) and setting in motion a cycle of hard-boiled thrillers that lasted a decade. Huston's screenplay for *Falcon* is an intelligent condensation of the novel: it preserves the dialog, cuts minor characters, omits Spade's parable about the Flitcraft case (a mini short story and the philosophical essence of Hammett's pre-Marxist worldview), and adds an allusion to Shakespeare ("the stuff that dreams are made of"). The photography and mise-en-scène, however, create a different impression from Hammett, whose style is minimalist. Huston is an expressive director and his film has an artfully stylized quality, employing extreme depth of field, low-level camera angles that bring ceilings into view, and editing of tightly framed shots that create a dynamic, foreboding sense of space.

The cast gives subtext and psychological depth to scenes Hammett had written flatly. Mary Astor's Brigid is always a bit visibly

deceptive and flirtatious, alternating between a sexy but genteel damsel in distress and a shady but vulnerable lady in trouble; she knows that Spade knows she's acting, and, as Spade says, that makes her "*really* dangerous." Bogart's Spade is tough, brooding, and edgy; when he kisses Brigid the first time he looks anguished, and when he announces he's turning her over to the police he looks almost desperate. Elsewhere, the performances emphasize the "masculine" ethos of Spade and the "femininity" of the villains, as in Peter Lorre's effeminate Joel Cairo and the veiled homosexual coupling of Sydney Greenstreet and Elisha Cook, Jr as Caspar Gutman and his "gunsel" Wilmer. (Hammett's term "gunsel" was underworld slang for a boy kept by an older man; Huston slipped it past censors who thought it meant gunman.)

The memorable last scenes of the film emphasize Gutman's resilience as he gaily wanders off in search of the black bird, Spade's Spartan calm as he walks away with the police, and Brigid's fear as she descends in an elevator cage. This version of *Falcon* could be described as an allegorical drama about the psychodynamics of masculinity; it romanticizes danger, but is also a subtly witty film, employing a swift, oblique, somewhat arch style of acting. The search for the bird is stylized enough to create a male myth rather than a slice of life, and Huston's wit is sly enough to humanize the action without destroying its power as melodrama.

In writing the novels Hollywood adapted for *The Thin Man* and *The Maltese Falcon*, Hammett was indirectly responsible for two of the most important film cycles of the 1930s and 1940s. He was an unusually "movie-like" writer, who possessed an ear for American speech and a sense of the texture of modern life. As John Huston recognized, Hammett's novels were virtual scripts, consisting of objective description and pungent dialogue. And yet Hammett had contempt for Hollywood, and Huston was the only director who gave his work cinematic distinction. In the 1940s, an accurate rendition of this popular but radically skeptical

novelist would have been politically controversial, morally challenging, and perhaps too artful for the studios.

Greene

In the years before World War II, Graham Greene (1904–91), along with fellow novelists Somerset Maugham and Eric Ambler, created a modernist school of British crime and spy fiction. The tradition Greene reacted against is remarked upon in his wartime novel *The Ministry of Fear* (1943), when the protagonist, speaking for the author, describes an older England: "People write about it as if it still went on; lady novelists describe it over and over in books of the month, but it's not there anymore." This speech is symptomatic of modernist disdain for a supposedly feminized mass culture, but is somewhat disingenuous, because Greene's first thriller, *Stamboul Train*, was a book of the month, and had been adapted as a movie in 1934.

The Oxford-educated son of a middle-class family, Greene was a convert to Catholicism and socialism, an admirer of T. S. Eliot, and a fond reader of the old-fashioned, international-intrigue novels of John Buchan, author of *The 39 Steps*, whom he praised for writing about "adventure happening to unadventurous men." He was also an ambitious novelist and an important film critic. Out of these interests, he fashioned a series of what he called "entertainments" about crime and espionage, which he wrote alongside his more literary fiction. Most of his novels, of whatever kind, were adapted for films, and the "entertainments" accounted for several key examples of 1940s film noirs.

Greene's entertainments take place in what reviewers called "Greeneland," a world of dingy-roomed houses, canned fish, and drooping aspidistras. The atmosphere resembles Eliot's Waste Land—an "unreal city" made up of cheap hotels, lonely typists, half deserted streets, newspapers blowing in vacant lots, and random scraps of popular tunes. Greene also adopted many of

Eliot's religious, racial, and cultural attitudes. As in Eliot (and in Buchan), there are anti-Semitic touches: the least sympathetic characters include a Jewish arms manufacturer who arranges the murder of a socialist war minister, a Jewish gangster with "raisin eyes" who controls the underworld in Brighton, and a Jewish pseudo-aristocrat who runs a super modern nightclub and resort called the Lido. In *A Gun for Sale*, the protagonist visits a back-room abortionist named Dr Yogel to have surgery performed on a hare lip; Yogel's fingernails are dirty, he smells of brandy, and he sweats as he approaches with a scalpel. But Greene is equally critical of American-style capitalism and kitsch, which one of his protagonists describes as "worse than the meanness of poverty, poverty of spirit." The city's poor urban areas in *A Gun for Sale* are set off against a depressingly modern housing development with fake Tudor designs and a street called "Shakespeare Avenue."

As a student, Greene was the film critic for *The Oxford Outlook* and an avid reader of *Close Up*, a modernist film journal to which Hilda Doolittle ("H.D.") and other literary figures contributed. Between 1935 and 1940, he was a film critic for London's *The Spectator* and *Night and Day*, and his reviews in those journals show his love of pre-war French film noirs, which foreshadowed the noir-like cinema he would help to create. Hollywood's "bright slick streamlined civilization" dismayed him, and he repeatedly complained about the mixture of sentiment and chrome-plated sleekness in big studio productions. Genre movies rarely provoked his interest. He described Paramount's first adaptation of *The Glass Key* as "unimaginatively gangster," and was equally unhappy with Hitchcock's *Sabotage* (Britain, 1936), an adaptation of Joseph Conrad's *The Secret Agent*, which, he argued, failed to capture the "dark drab passionate" qualities of the book.

Greene admired French filmmakers above all, because they were both drably realistic and "poetic." (Had he known the term "poetic realism," which historians now use to describe French films of the period, he would have embraced it.) The most enthusiastic

of his reviews was for *Pépé le Moko*, which impressed him with its sordid detail: "it would be hard to equal the shooting of Regis, the informer, with its comic horror: the little fat eunuch sweating and squealing in the corner between the aspidistra and the mechanical piano, the clash and clatter of the potted music as his dying friend is helped across the room to finish him off at point-blank range, friends steadying the revolver on its mark." In *Hôtel du Nord*, he noticed "the tuft of cotton-wool in the young man's ear which seems to speak of a whole timid and untidy life." And in the Julien Duvivier episode of *Carnet de bal*, he found effects that would appear in his fiction: "the seedy doctor at Marseilles, so used to furtive visitors and illegal operations that he doesn't wait for questions before he lights the spirit flame: the dreadful cataracted eye: the ingrained dirt upon his hands; the shrewish wife picked up in God knows what low music hall, railing behind bead curtains: the continuous shriek and grind of winch and crane." These and other French film noirs convinced him that "if you excite your audience first, you can put over what you will of horror, suffering, truth." The best formula was "blood melodrama," but England lacked such films because of its attachment to "middle-class virtues." The solution was to "dive below the polite level, to something nearer to common life." If British filmmakers could develop "the scream of cars in flight, all the old excitements at their simplest and most sure-fire, then we can begin—secretly, with low cunning—to develop our poetic drama."

Greene followed the lead not only of the French but also of T. S. Eliot, who had praised the native English tradition of bloody revenge tragedy. The mutually reinforcing influence of Eliot, Jacobean revenge dramas, and pre-war French cinema can be seen in nearly all of Greene's entertainments. *A Gun for Sale*, for instance, is a revenge tragedy set in an urban wasteland, featuring a violent, "cinematic" opening chapter and a veiled religious motif (a hired killer becomes a scapegoat and ironic Christ figure). But the three influences are most evident in *Brighton Rock* (1938),

Greene's most ambitious thriller, which he didn't label an "entertainment." The story involves a gang war in the resort town of Brighton, set in motion when a sadistic, baby-faced killer named Pinkie Brown tortures and murders a small-time journalist who indirectly assisted in the murder of Pinkie's boss. A bosomy barmaid named Ida Arnold, who has enjoyed casual sex with the journalist, becomes a sort of detective and agent of vengeance. Meanwhile, Pinkie seduces, impregnates, and marries Rose, a devoutly Catholic working girl, to prevent her from revealing evidence to the police. Eventually he gives her a revolver and proposes a mutual suicide pact that he has no intention of joining: "Put it in your ear—that'll hold it steady." Police arrive just in time, and Pinkie kills himself by jumping over a cliff. Rose, disturbed because he died without forgiveness of his sins, goes to a priest, who consoles her by pointing out that Pinkie loved her: "surely that shows there was some good." The novel ends as Rose returns to her room to listen to a recording Pinkie made for her on Brighton Pier. She doesn't know, but we do, that the message on the record is "God damn you, you little bitch, why can't you go home forever and let me be?"

This may sound like a simple conflict between good and evil, capped with a nasty twist. But Greene's aims are complex. Pinkie is both a working-class Catholic and a Satanist, obsessed with "Good and Evil." He enjoys slicing people with razors, he's disturbed by sex, and he feels spasms of venom at the Americanized resort culture of Brighton. His antagonist, Ida, is a sentimental humanitarian who believes in "right and wrong" and cries over Hollywood movies because "easy pathos touched her friendly and popular heart." Between the twisted Catholic and the female symbol of Mass Culture, Greene feels more sympathy for Pinkie, for the same reason that T. S. Eliot had sympathy for the Catholic Satanist Charles Baudelaire. In Eliot's view, such a man might choose Satan and be damned; but in the new world of social reform, damnation was a "form of salvation—of salvation from the ennui of modern life."

The first Hollywood adaptation of a Greene thriller was Paramount's *This Gun for Hire* (1942), based on *A Gun for Sale*, which elevated Alan Ladd and Veronica Lake to stardom. The film differs in important ways from the novel: it changes locale to America, makes the villains Nazi fifth-columnists, largely omits Greene's anti-capitalism, provides a beautiful female love interest (who both sings and does magic tricks), and converts the hired killer from a man with a harelip to a strikingly handsome fellow with a broken, improperly set left wrist. It nevertheless has darkly atmospheric elements that set off Ladd and Lake's California blondness, and a memorable treatment of violence. In one of its opening scenes, the youthful, coolly lethal Ladd shoots a man as if delivering the mail. Borde and Chaumeton named it a seminal film noir because it established a new character type—the "angelic killer"—and the convention of surreal chases through an urban setting.

Other adaptations followed: Fritz Lang's Hitchcock-like *The Ministry of Fear* (1945), which changed the protagonist from a man with bad teeth to the handsome Ray Milland, and *The Confidential Agent* (1945), which does a better job of suggesting "Greeneland." A film that comes even closer to Greene's world is the British production of *Brighton Rock* (1947), scripted by Greene and Terence Rattigan, with Richard Attenborough as "angelic" killer Pinkie Brown. The ending isn't as dark as the novel, but nevertheless disturbing.

The film that best fulfills Greene's dream of a thriller that could serve as art, however, is Carol Reed's *The Third Man* (Britain, 1949; Figure 6), with a screenplay by Greene that was later "novelized" for publication. Early in his career, Greene had re-read Conrad's *Heart of Darkness*, noting in his diary that it was possible to write finely within the conventions of adventure. *The Third Man* resembles that novella in some ways. The protagonist, Holly Martins, like Conrad's Marlow, is a naive romantic who journeys to a foreign country and finds a charismatic figure of evil.

6. *The Third Man* (**Britain, 1949**).

The villain, Harry Lime, like Conrad's Kurtz, makes a delayed entrance after being described by several people, one of whom (named Kurtz) tells Martins that he was Lime's best friend, "after you, of course." There are Greene-like religious references ("Of course I still *believe*, old man," Lime tells Martins, "I'm not hurting anybody's *soul* by what I do."), plus dizzily canted camera angles, a chase through the sewers of Vienna, unforgettable zither music, and a star performance by Orson Welles as the Luciferian/angelic killer who counterpoints the drab "Greeneland" of bombed-out, post-World War II Vienna. (Welles wrote the most famous speech in the film, favorably comparing the murderous Borgias to the democratic Swiss.)

"Don't be melodramatic, old man," Harry Lime says to Holly Martins as they ride the giant Ferris wheel above Vienna. But Lime, whose name has an affinity with "Greene," is the most melodramatic figure in the film, a dashing outlaw reminiscent of the Shadow. Martins adores him, as does the masochistically

romantic Anna (Alida Valli), who pines for him even after he has turned her over to the authorities in the occupied Russian zone of the city. In this film, however, the seductions of melodrama are never offered without irony or deflation. Lime, a witty sociopath, chews antacid tablets as he rides the Ferris wheel and projects a fake bonhomie. Martins, an American "scribbler" of pulp westerns who has experienced outlaws only in his imagination, is a lonely outsider with an unrequited crush on Anna. *The Third Man* brings two different kinds of pleasure into melancholy union: the flourishes and intensities of melodrama are treated with modernist skepticism, and the realistic depiction of everyday life is haunted by bloody and romantic passion.

Cain, Chandler, and Wilder

James M. Cain (1892–1977) began as a journalist and university teacher, and before becoming a novelist was briefly an editor of *The New Yorker*. The first sentence of his best-selling 1934 novel *The Postman Always Rings Twice* ("They threw me off the hay truck about noon.") is pure hard-boiled, but he never wrote for the pulps. Influenced by the naturalism of Theodore Dreiser and the tough modernism of Ring Lardner, he became famous for stories about criminal psychology among the rootless lower and middle classes in California. Critics discussed his work alongside that of such highly regarded novelists as John O'Hara and Nathaniel West. Cain himself said that he was interested in a type of American tragedy dealing with the force of circumstance that drives individuals to dreadful acts. In stylistic terms, he was closer to melodramatic opera (he had once hoped to be an opera singer), in which individuals are swept along by currents of desire. His characters have deadpan voices but behave like lovers in *Carmen*. His strength as a writer is his ability to treat them with Flaubertian detachment.

Hollywood was slow to adapt the extremely popular but too steamy *Postman*. France and Italy, where censorship restrictions

were less puritanical, filmed it first, and when MGM finally adapted it in 1946, studio publicity claimed that a kiss between Lana Turner and John Garfield had been timed with a stopwatch to reach but not exceed censorship limits. But because of the success of the novel, Cain was invited to Hollywood early in the 1930s, where he became a generally undistinguished screenwriter who developed a love of California. In 1944, Billy Wilder read Cain's somewhat less daring 1936 novella *Double Indemnity*, which had first appeared in the slick-paper magazine *Liberty*. That journal was famous for printing the reading time for its stories, and said the novella would require "2 hours, 50 minutes, and 7 seconds." Wilder claimed to have finished it in fifty-eight minutes because he didn't move his lips.

Wilder decided to film *Double Indemnity* (Figure 7), even though Hollywood's powerful censorship agency, the Production Code Administration (PCA), founded by Will Hayes in the 1920s but now headed by Joseph Breen and known in the industry as the "Breen Office," ruled against an adaptation. The PCA's chief objection was that the protagonists, Walter Huff and Phyllis Nirdlinger, get away with murder (at the end of the novel, Phyllis hovers behind Walter, ready to kill again). Wilder agreed to make the killers pay for their crime, but the ending he originally filmed was revenge against the PCA: a chilling, blow-by-blow depiction of execution in the California gas chamber, which was cut and apparently lost before the picture was released. The resulting film was nevertheless a challenge to existing PCA standards on at least three grounds. It depicts an attractive pair of killers (Walter Neff and Phyllis Dietrichson, played by Fred MacMurray and Barbara Stanwyck) who escape the law and die by their own hands; it treats adultery in cavalier fashion; and it gives details of the planning of an elaborate crime.

Cain was unavailable for collaboration with Wilder on the screenplay (he wrote none of the famous pictures based on his novels, including the excellent, female-centered film noir *Mildred*

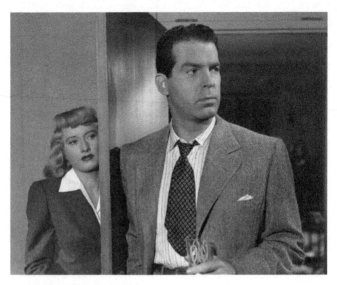

7. *Double Indemnity* (1944).

Pierce (1945)) but Wilder made an inspired choice to replace him: Raymond Chandler (1888–1959), who had the same publisher and literary agent as Cain and was author of the best hard-boiled fiction since Hammett. Theirs was a prickly but productive relationship. Wilder had always worked happily with another writer because he was insecure about his English; but Chandler, who was 60 and new to the movies, resented Wilder's daily martinis, women friends, and habit of gesturing with a riding crop. Chandler nevertheless later said that he learned everything he knew about screenwriting from Wilder, and Wilder recalled that he learned everything he knew about good dialog from Chandler: "that's all he could write," Wilder said. "That, and descriptions."

In fact Chandler had little talent for plot or structure, which Wilder provided, but was a brilliant prose stylist. He differed from Cain, whom he also disliked, in being a romantic whose tough but

eloquently written novels suggested nostalgia for an old civilization. Born in Chicago, Chandler moved at an early age to England, where he was raised in London and educated at Dulwich College. His distinctive style was the product of a classical British education encountering demotic American speech. No less than Wilder, he was a cultural outsider who adjusted to America and made art from it. He had turned to pulp fiction after drinking himself out of a job as an executive in a California oil business, and he tended to resent modernized organizations that could pay for his skill. When he came to work with Wilder, he commented on "the psychological and spiritual kinship between the operations of big money business and the rackets." He once said that "the best American writing has been done by men [*sic*] who are, or at one time were, cosmopolitans...they had to have European taste to use the material." Describing his attitude to modern American life, he remarked, "I should prefer an amiable drunk to Henry Ford."

Although he made his living in the popular media, Chandler's novels were grounded in the modernist belief that the modern world is destructive of culture. Philip Marlowe, his tough private eye, had a British-sounding name, a wryly critical attitude toward California, a gift for similes, and an American facility with wise-cracks. Marlowe's voice, which resembled Chandler's own, was modified in Hollywood, especially in Howard Hawks's apolitical but amusingly sinister adaptation of *The Big Sleep*. (Other Hollywood adaptations of Chandler in the period were *Murder, My Sweet*; *Lady in the Lake* (1947); and *The Brasher Doubloon* (1947). Only the first of these had traces of Chandler's verbal style.) But that voice can be heard everywhere in *Double Indemnity*, which gets its best effects from words. The leading characters are more literate than in Cain; they use language as a weapon or mode of seduction, and their longer speeches, such as the "speed limit" conversation between Walter and Phyllis, have flair. The affectionate banter between Walter and claims investigator Barton Keyes (Edward G. Robinson) resembles a story conference between a couple of cynical Hollywood writers and is

capped by a show-stopping long speech in which Keyes recites actuarial statistics. Walter occasionally speaks a salesman's corny patter, but also composes the world's most memorable Dictaphone message, full of Chandleresque details, such as his description of the Dietrichson household: stale cigar smoke, dust motes, and "a bowl of those little red goldfish behind the davenport."

Cain, Chandler, and Wilder all were critics of modern industrial America. Cain's inspiration for the novella was a story he heard about a typesetter at a big newspaper, a cog in the system who couldn't resist changing a letter in a word to make it salacious. (Cain was also inspired by the 1920s "tabloid murder" story of Ruth Snyder, who bludgeoned her husband to death and was the first woman to be executed in the electric chair.) The true cosmopolitan associated with the film, however, was Wilder, who had been a journalist in Vienna, a screenwriter in Berlin, and a director in Paris before escaping Hitler's conquest of Europe. This explains why *Double Indemnity*, which differs in many ways from the novel, has so much in common with Weimar German cinema—not only in visual style but also in its vision of Fordist America. As William Luhr has pointed out, the film's language is filled with deterministic industrial metaphors: the lovers commit to murder "straight down the line"; Walter devises a clockwork plan involving a train; and when the plan is put in motion, "the machinery had started to move, and nothing could stop it." Fate, Walter says, had "thrown the switch" and "gears had meshed." The production design reinforces these metaphors: Pacific All Risk Insurance is a cavern filled with scores of identical desks and reading lamps; Walter eats at a drive-in restaurant, bowls alone at a huge alley, and secretly discusses murder in the canned-food aisles of "that big market up at Los Feliz."

The Weimar element is equally evident in the treatment of Phyllis Dietrichson, who incarnates modernist fears of the "new woman" and is an updated version of the robotic "false Maria" in *Metropolis*. The femme fatale in Cain's novella is an ordinary,

earthy woman with a "washed out face" and a "shape to set a man nuts," but the character portrayed by Stanwyck is beautiful, blatantly provocative, and visibly artificial: her ankle bracelet, her lacquered lipstick, her sunglasses, and above all her chromium hair give her a manufactured, metallic look. Her sex scenes are almost affectless, and she reacts to murder with icy composure. "She was perfect," Walter says, "No nerves, not a tear, not even a blink of the eye." The big sex scene between Walter and Phyllis is left for us to imagine, but the aftermath looks relatively mechanical. More warmth is generated by the platonic relationship between Walter and Keyes, two organization men who become an Odd Couple. One of the ironies of Walter's crime is that in betraying his employer he also betrays his friend, who remains a servant of bureaucracy. His interoffice message to Keyes is not only a confession of guilt but also an admission that the "I love you, too" he has often jokingly said to Keyes—and says again in the last line of the film, with a blood-stained cigarette in his mouth—is the truth.

Wilder's original version of *Double Indemnity* would have gone further, showing Keyes visiting Walter in prison and witnessing his execution in the California gas chamber—the culminating instance of instrumental rationality and the "end of the line" for industrial culture. When the lonely Keyes exited, we would have seen him patting his pockets, as he has done throughout, looking for a match to light his cigar, and realizing that Walter is no longer there to give him one. The darkest irony of this original ending, of which Wilder was unaware at the time, was that Wilder's mother had recently died in an Auschwitz gas chamber.

And company

There is insufficient room here to account for all the ways fiction writers have influenced film noir, but other cases should be noted. Chief among them is Cornell Woolrich (1903–68), the most prolific of noir writers and the most adapted for film, radio, and

TV. Less stylish or literary than the figures I've been discussing (his language is sometimes empurpled, and his plots can be awkward), Woolrich wasn't a hard-boiled or spy-thriller specialist. He owes something to Edgar Allan Poe's terror tales, but his suspenseful fiction is usually set in a modern world of guilt, anxiety, paranoia, and claustrophobic entrapment. Some of his prose has the deliberately repetitive, incantatory quality of an anxiously beating heart or the incessant drip of water torture. Consider the opening of *The Black Curtain*: "Then he could feel hands fumbling around him. They weren't actually touching him; they were touching things that were touching him." Or consider this from *The Black Angel*: "He looked at the wall opposite him, and it wasn't to be found there. He looked at the ceiling, and it wasn't there. He looked at his empty hands, and it wasn't there." Such language is typical of Woolrich's obsessive characters, who tend to suffer from amnesia and alcoholic blackouts or fall into situations in which nobody believes them. Many of his plots border on the fantastic or have an is-this-happening-or-am-I-crazy quality. They sometimes end happily—hence Woolrich's popular success and adaptability—but they leave an aftertaste of dread.

Woolrich's life story is also dreadful, even tragic. Born in New York, he was a child of divorce and lived for a while with his father in Mexico before moving back to Manhattan to live with his mother. He attended Columbia University and began his writing career with unsuccessful imitations of Scott Fitzgerald's jazz-era novels. After a brief, equally unsuccessful stint in Hollywood, he returned in the 1930s to New York and took up crime fiction, at which he became so speedy and proficient that he eventually wrote under his own name and two pen names (William Irish and George Hopley). Although he earned a great deal, he and his mother lived in seedy New York hotels until her death in 1957. He then moved to a better hotel and became a recluse. A closeted homosexual who probably suffered from sexual guilt, Woolrich was alcoholic, emaciated, and diabetic. Because of an untreated foot infection (all too susceptible to

Freudian analysis), one of his legs was amputated and he spent his last years in a wheelchair.

One of Woolrich's distinctive contributions to the form of the thriller was to heighten suspense by making the "detective" character a vulnerable amateur—a female secretary, a young housewife, a woman who changes her identity to escape a brutal lover, a man who suffers from amnesia and fears he may have killed someone, a traumatized veteran, a pre-adolescent boy, or a witness to murder who is confined to a wheelchair. Unlike detectives in classic whodunits or tough-guy thrillers, such characters are always in danger of being the next murder victim.

Film, radio, and television adaptations of Woolrich using this formula are far too numerous to list; he's been adapted not only in Hollywood but also in Europe, Latin America, Japan, and Russia. Among the best of the US films are Val Lewton and Jacques Tourneur's low-budget horror picture *The Leopard Man* (1943), Roy William Neill's *Black Angel* (1946), and Arthur Ripley's *The Chase*. One of the most celebrated is Robert Siodmack's *Phantom Lady* (1944), produced by Hitchcock's talented associate Joan Harrison and starring Ella Raines as a secretary who attempts to prove her boss isn't guilty of murdering his wife. The hunt for the real killer involves a search for a mysterious woman in a flamboyant hat; it leads through a studio-created, hallucinated New York, and puts the secretary in a number of suspenseful situations, including a late-night encounter with a strange man on a deserted train platform. *Phantom Lady* also features Elisha Cook, Jr, the quintessential noir character actor, as a sex-crazed jazz drummer. A delirious montage depicting one of his midnight jam sessions goes very far over the top, but is nonetheless unforgettable.

Two outstanding film noirs were based on Woolrich short stories about relatively powerless characters who witness a murder through a window and can't find anyone to believe them. The first,

Ted Tetzlaff"'s *The Window* (1949), centers on a boy with a vivid imagination and a habit of telling tall tales who lives with his working-class parents in a New York tenement. The boy's parents are more sympathetic in the film than in Woolrich's story and the killer is less brutal, but *The Window* has an impressively realistic atmosphere and considerable suspense.

The second film, arguably the best of all adaptations of Woolrich (though it isn't always classed as noir and differs from Woolrich by virtue of its humor and wit), is Hitchcock's *Rear Window* (1954), with James Stewart confined to a wheelchair for the entire action. Hitchcock adds a glamorous love interest in the person of Grace Kelly, and his designers create an elaborate, dolls-house set representing a Greenwich-Village apartment house and courtyard where a variety of characters go about their daily lives. A tour-de-force of claustrophobic suspense, *Rear Window* is also a sustained demonstration of the "Kuleshov effect," an editing technique named for Russian theorist Lev Kuleshov, who showed how meaning is created by cutting from a shot of a character looking offscreen to a shot of what the character sees. Hitchcock cleverly amplifies the effect and adds suspense by making the wheelchair-bound "detective" a photographer armed with telephoto lenses, which create closeups of the activity he spies across the courtyard.

Another of film noir's literary sources is the "heist" novel, which, like *Double Indemnity*, ironically mimics industrial rationality. It seems to have originated with W. R. Burnett's 1949 *The Asphalt Jungle*, adapted by John Huston in 1950. Huston's film created a trend: Jules Dassin's *Rififi* (France, 1954) was based on a 1953 novel by Auguste Le Breton, and Stanley Kubrick's *The Killing* (1955) was derived from Lionel White's 1954 *Clean Break*. Such films usually have a rob-from-the-rich plot that creates sympathy for the criminal gang's ingenious planning. When film censorship became more liberal after the 1960s, the gangs often got away with their crime, as in Steven Soderbergh's *Logan Lucky* (2016).

But something was lost in the process of letting crime pay; the original heist films had a doomed fatality more appropriate to the moods of noir.

Some of the toughest crime novels centering on women or minorities haven't been filmed—see especially Sara Gran's *Dope*, involving a female PI who is a recovering addict barely off skid row, and James Sallis's *The Long-Legged Fly*, about a black detective in New Orleans. The major black writer of tough crime fiction in the 1940s and 1950s was Chester Himes, whose Harlem detective novels weren't adapted until the 1960s, and none of the adaptations captured the violent absurdity of his fictional world. Still another important tough writer who has yet to be filmed is Jean-Patrick Manchette (1942–95), a French novelist who was influenced by Guy Debord's critique of the "society of the spectacle" and who in recent years has received excellent English translations.

Among writers of more perverse sorts of fiction, Jim Thompson (1906–77) was initially too disturbing for film. His cheap paperbacks of the 1950s attracted the attention of Stanley Kubrick, who hired him as screenwriter, but Thompson wasn't recognized as an important author until after his death. His first-person narrators are twisted sociopaths or nihilistic con men, and his plots—especially *Savage Night*—are more nightmarish and grotesque than anything in Nathaniel West. Several post-1950s films have been based on his work, among them Alain Corneau's *Série noire* (France, 1979), Bernard Tavernier's *Coup de torchon* (France, 1981), Stephen Frears's *The Grifters* (1990), and Michael Winterbottom's *The Killer Inside Me* (2010).

An equally dark but more humorous novelist was Charles Willeford (1919–88), whose *High Priest of California* is the story of a sociopathic used-car salesman who enjoys reading Joyce, Eliot, and Kafka. Here, as in *The Woman Chaser* and *Kiss Your Ass Goodbye*, Willeford is a clever satirist of the male ego who has

a deceptively casual way of digressing from plots to explore character. Three films have been based on his work: Monte Hellman's *Cockfighter* (1974), George Armitage's *Miami Blues* (1990), and Robinson Devor's *The Woman Chaser* (1999). Other tough noir novelists who have been important to movies are Elmore Leonard (1925–2013), adapted for *52 Pick-Up* (1986), *Jackie Brown* (1997), *Out of Sight* (1998), and the comic noir *Get Shorty* (1995); James Ellroy (b. 1948), adapted for *L.A. Confidential* (1997) and *The Black Dahlia* (2006); and Richard Stark (aka Donald E. Westlake, 1933–2008), screenwriter for *The Grifters*, whose novels were adapted for *Point Blank* (1967), *Mise à sac* (France, 1967), and *Le Couperet* (France, 2005).

But these exponents of hard-boiled writing are only one strand of crime fiction that has influenced dark films. Kenneth Fearing's *The Big Clock*, a study of murder in corporate publishing, rubs shoulders with high modernism; unfortunately the highly entertaining 1948 film adaptation doesn't retain Fearing's unsympathetic protagonist, multiple-perspective narration, and unorthodox ending. And although the first cycle of 1940s Hollywood noir was based mostly on male writers, there have been many fine women authors of noir novels, among them Vera Casperay (the source of *Laura*), Dorothy B. Hughes (the source of Max Ophuls's *The Reckless Moment* (1949)), and above all Patricia Highsmith, who has been adapted many times, starting with *Strangers on a Train* and leading eventually to a number of films about Tom Ripley, a murderer who becomes a paradoxical hero living a prosperous life in a French country home (among the Ripley films are Rene Clément's *Purple Noon* (France, 1960), Wim Wenders's *The American Friend* (Germany, 1977), and Anthony Minghella's *The Talented Mister Ripley* (1999)). None of the many Highsmith adaptations has fully captured her lucid, fastidious irony, but in my view Hossein Amini's *Two Faces of January* (2014) comes close.

Classic Hollywood noir, influenced by modernism, has in turn influenced writers of postmodern, non-generic novels, including Paul Auster (*The Manhattan Trilogy*), Jonathan Lethem (*Motherless Brooklyn*), and Thomas Pynchon (*Inherent Vice,* which was adapted for a P. T. Anderson film in 2014). There seems no end to noir fiction or movies based on it, but it should be noted that the "guilty vicarage" form W. H. Auden described has by no means disappeared or waned. Agatha Christie remains the best-selling author of all time, and *Murder on the Orient Express* has had two star-filled movie adaptations (1974 and 2017). See also such latter-day British and European TV series as *Inspector Morse, Shetland, Broadchurch,* and *Blood of the Vine*—all set in small, picturesque locales where murders happen every new season or episode and need to be solved so that Eden can be restored.

Chapter 3
Censorship and politics in Hollywood noir

The Production Code

During the period when American film noir was at its zenith, Hollywood's self-appointed censorship agency, the Production Code Administration, exercised control over the movie studios. There were also boards of censors in some states, and foreign censors with their own standards; in certain localities, audiences for *The Maltese Falcon* didn't see Wilmer kick Sam Spade in the head.

Executives in Hollywood claimed to be interested in entertainment rather than politics, but the PCA's standard report form of the 1940s was manifestly puritanical and ideological, containing prohibitions against "lustful kissing," excessive drinking, visible pregnancy, adultery, "perversion," and miscegenation. One of its General Principles was that "law, natural or human, shall not be ridiculed, nor shall sympathy be created for its violation." Elsewhere it contained specific warnings against criticism of police, clergy, and government officials. Chief watchdogs over such things were Joseph Breen, head of The Motion Picture Producers and Distributors of America (MPPDA), and Martin Quigley, co-author of the Code provisions. Both were staunch Catholics (and privately anti-Semitic). Breen was inclined to favor certain types of social-problem pictures, but with qualifications: "When people talk about realism," he declared, "they usually talk about filth."

Given this situation, we might wonder how definitive examples of American film noir could have been made. In such films, the line between sympathetic and unsympathetic characters is often blurred and the ordinary criminals are sometimes more appealing than the brutal cops, inept judges, and murderous lawyers who represent official society. Furthermore, most of the films are intensely preoccupied with lust, eroticism, or "perversion."

One strategy for getting past Breen and Quigley was to make sure crime never paid: no matter how sympathetic, criminals were caught and usually punished by the law, and crooked officials came to a bad end. Where sex was concerned, anyone who looked queer was made a villain, as with the vaguely homosexual aesthetes in *The Maltese Falcon* and *Laura* or the Fascistic prison guard in *Brute Force* (1947). Relatively little skin was on display. Women were eroticized with fetishistic details, such as Barbara Stanwyck's ankle bracelet in *Double Indemnity* or Rita Hayworth's backlit hair in *Gilda* (Hayworth's striptease in that film involves nothing more than removing a pair of long black gloves). Sexual intercourse was suggested by fade-outs and ellipsis, often accompanied by romantic music, shadowy lighting, and watery images. In a suggestive post-coital scene in *Possessed* (1947), the fully dressed Van Heflin and Joan Crawford converse in a brightly lit room; he's smoking a cigarette and "making love" to a piano while she looks out a window at a moonlit lake and contemplates a swim. On a stormy Acapulco night in *Out of the Past*, Robert Mitchum and Jane Greer enter a room lit by a single lamp, which throws high shadows on the wall. Mitchum puts romantic music on the radio and uses a towel to dry Greer's wet hair. He embraces her, and the camera swiftly pans away from him as he tosses the towel across the room and over the lamp. A gust of wind from the storm suddenly blows through the open doorway, knocking the lamp to the floor. The camera drifts outside and moves along the veranda in the rain for a few moments. Fade out.

According to Borde and Chaumeton, this sort of indirection had a positive effect: "the necessity for innuendo promoted a type of lighting that could not but enhance the suggestive power of the images." There was also something suggestive about what Borde and Chaumeton called noir's "ceremony of violence." Characters may have been savagely beaten in dark alleyways or dropped down elevator shafts, but there were no rivers of blood, amputated body parts, or slasher imagery of the kind that terrified audiences in Hitchcock's landmark *Psycho* (1960). The horrific gang rape in *Touch of Evil*, for example, is preceded by suggestive details: a rapist lasciviously licks his lips and Mercedes McCambridge (perhaps speaking for a few in the audience) says, "Lemme watch!" But when the camera anxiously rushes toward the action, an open motel room door slams shut in its face. Later, we're told the rape never happened; it was merely staged to terrify Janet Leigh. This doesn't diminish the shock.

The treatment of sex and violence became a bit more explicit around 1950, when paperback novels flooded bus stations and drug stores with cover images of semi-clothed women (the covers of today's paperbacks from Hard Case Crime are a pastiche of the style). This influenced two film thrillers from 1953: *Niagara*, a Technicolor spectacular starring Marilyn Monroe, and *I, the Jury*, a 3-D exploitation picture based on the runaway success of the Mickey Spillane paperbacks. Both productions were situated in a transitional zone between an older, repressed darkness and an emerging world of *Playboy* and James Bond. Meanwhile, bloody violence could be seen in noir-like boxing pictures, especially *Champion* (1949) and *The Harder They Fall* (1956), which was Bogart's last role. *On the Waterfront* (1954) owed something to these, and Martin Scorsese's *Raging Bull* (1980) harked back to them. But the noir boxing cycle was obliterated by the up-from-the-bootstraps, Reagan-era optimism of the *Rocky* franchise. At its height, it was virtually indistinguishable from Clifford Odets-style social realism.

Political censorship

Social realism, a hallmark of the New-Deal pictures at Warner Bros in the early 1930s, became an important aspect of 1940s film noir, in part because of a Hollywood coalition of writers and directors from Europe and New York who were associated with the Popular Front, an alliance of liberal, socialist, and communist groups that had formed in reaction against the rise of European fascism. Historians have sometimes ignored or undervalued this development, claiming that noir in the period was bleakly apolitical; Paul Schrader, for example, describes its essential tone as "hopeless" and "relentlessly cynical." But even if we leave aside the question of how such a cinema could have become an object of nostalgia, there is very little evidence that the people who created it were cynics. Many of the directors—including John Huston, Orson Welles, Edward Dmytryk, Jules Dassin, Joseph Losey, Robert Rossen, Abraham Polonsky, and Nicholas Ray—belonged to Hollywood's liberal or left-wing community. Dashiell Hammett, Graham Greene, and Eric Ambler were socialists or Marxists, Vera Casperay briefly belonged to the Communist Party, Dorothy B. Hughes was anti-fascist, and Raymond Chandler and James M. Cain were regarded in some quarters as social realists. Bogart and John Garfield were icons of liberalism and left activism, and noir screenwriters Albert Maltz, Howard Kotch, Waldo Salt, and Dalton Trumbo were among many leftists who were subsequently blacklisted.

A more accurate account of the period would show that while American noir has no essential politics, its formative roots were in the left culture of the Roosevelt years—a culture that was repressed in the post-war decade, when noir took on cynical and even right-wing implications. Paradoxically, however, popular culture throughout the period was subject to many political forms of censorship. During World War II and the years after, the US government's Bureau of Motion Pictures and Office of War

Information promoted official policy, and the government Office of Censorship oversaw foreign distribution of films. At a non-government level, left organizations such as the Writers' Guild of America, the Writers' Mobilization Congress at UCLA, and the Communist Party's Writers' Clinics pushed for anti-fascist but upbeat screenplays. After the war, the House Committee on Un-American Activities (HUAC) launched an investigation into communism in Hollywood.

Meanwhile, sociologists began to describe the 1940s cycle of dark crime films as symptoms of angst and moral decay. In 1946, at the moment when Borde and Chaumeton were discovering American film noir, Siegfried Kracauer, a German émigré to the US who had authored a study of Weimar cinema entitled *From Caligari to Hitler*, wrote a think-piece for *Commentary* magazine, posing the question "Hollywood's Terror Films: Do They Reflect a State of Mind?" Kracauer argued that *Shadow of a Doubt* (1942), *The Lost Weekend*, *The Stranger* (1946), and *The Spiral Staircase* were similar to German films of the 1920s and symptomatic of growing American decadence. A year later, Hollywood producer John Houseman made the same argument in *Vogue*, implicitly criticizing his former writer Raymond Chandler for the cycle of "tough" films about "a land of enervated, frightened people with spasms of vitality but a low moral sense." If we account for all these governmental and semiofficial forces of both left and right, film noirs made in the years between 1941 and 1955 were probably the most regulated, censored, and morally scrutinized pictures of the kind in American history.

As historian Nancy Lynn Schwartz has shown, conservatives who had been silent during the war were able to achieve victory over the cultural left in Hollywood through two forms of censorship: an "objective" pressure on filmmakers from the Republican-controlled Congress, the California senate, the Hearst press, and the right-wing Motion Picture Alliance; and a growing atmosphere of self-censorship from within the industry,

which led to "before-the-fact editing of writers and other creators." This strategy began to pay dividends for the right in 1947, which, ironically, given the films released that year, might be described as the *annus mirabilis* of noir. It was also the year of the Taft–Hartley Act forbidding communists in labor unions, a White-House executive order requiring government employees to take loyalty oaths, and the opening of the HUAC investigations. Over the next several years, many creative and craft workers in Hollywood were fired, briefly imprisoned, or blacklisted. Directors Joseph Losey, Jules Dassin, and Orson Welles spent over a decade working in Europe, and blacklisted screenwriters found work only if they had a "front" who claimed to write their scripts. Others, such as Vera Casperay, were "gray listed" and found it difficult to work. The purge was facilitated by an economic downturn in the industry, the decline of the studio system, and a consolidation of studio management. Radical actress Karen Morley commented, "The right wing rolled over us like a tank over wildflowers."

Even before the blacklist began, censorship affected makers of two excellent, commercially successful noir pictures made immediately after the war, which can serve as examples of political forces at work. The first, *The Blue Dahlia* (1946), which has an Academy-Award-nominated screenplay by Raymond Chandler, ends differently than Chandler planned because of pressure from the military. The outline he submitted to Paramount was rather like a noir version of *The Best Years of our Lives* (1946), dealing with three returning naval fliers, one of whom suffers from a head injury that causes spasms of violence followed by blackouts. Chandler later explained to a correspondent that the film was supposed to be about how the injured character "killed (executed would be a better word) his pal's wife, then blacked out and forgot all about it; then with perfect honesty did his best to get his pal out of a jam, then found himself in a set of circumstances that brought about partial recall. The poor guy remembered enough to make clear who the murderer was, but never realized it himself."

This scenario was disliked by the Department of the Navy, which asked Paramount to avoid a film depicting a naval veteran as a killer. "What the Navy Department did to the story," Chandler said, "was a little thing like making me change the murderer and make a routine whodunit out of a fairly original idea."

The film's producer, John Houseman, wrongly claimed in his memoirs that the ailing, alcoholic Chandler never had an ending and finished his screenplay only when he could write under the influence of bourbon with a studio nurse present. The bourbon part of this account is probably true. Significantly, the final screenplay begins with three characters entering a bar and asking for "bourbon with a bourbon chaser," and ends with one of them saying, "Did somebody say something about a drink of bourbon?"

The second film, *Crossfire* (1946), a tense, shadowy police procedural about an anti-Semitic US soldier who murders a civilian Jew, had to overcome PCA objections but encountered no problems with the military. Based on a Richard Brooks novel about the murder of a homosexual that Joseph Breen had declared unacceptable "on a dozen or more counts," *Crossfire* made many changes from its source, becoming a story about nativist fascism in America. The PCA was nevertheless troubled by the script and gave several orders: racial epithets should be eliminated, drinking and drunkenness should be minimized, there should be no suggestion that a young woman named Ginny (Gloria Grahame) is a prostitute or that a strange man in Ginny's apartment (Paul Kelly) should appear to be her customer, and the film shouldn't give the impression of "special pleading against current anti-Semitism."

The completed picture followed most of the orders. It retained two epithets ("Jewboy" and "Mick"), it had one scene of drunkenness and many in which coffee is consumed, and it made Ginny a relatively soft-boiled taxi dancer. As for the man in Ginny's apartment, he was turned into a sinister but blackly humorous

enigma. "You're wondering about this setup, aren't you?" he says to the police. "I want to marry her. Do you believe that? Well, that's a lie…I don't love her, and I don't want to marry her. She makes good money there. You got any money on you?" The audience is deliberately left to think up their own interpretations.

Crossfire was filmed at RKO by social-activist producer Adrian Scott, director Edward Dmytryk, and screenwriter John Paxton, who were responsible for two other noir pictures, *Murder, My Sweet* and *Cornered* (1945). It got strong backing from RKO studio chief Dore Schary, who was famous for social-problem productions. The completed film won five Academy-Award nominations and a prize for "social drama" at the Cannes festival. A year after its release, however, it was listed by HUAC as a key example of communist influence in Hollywood. On the heels of their greatest success, Scott and Dmytryk were called before HUAC, where they refused to name communists they had known. As a result, they were among those mentioned in the 1947 "Waldorf Declaration," written by the most powerful executives in the movie industry (including Dore Schary), which described them as having done "disservice to their employers" and "impaired their usefulness to the industry." They were members of what came to be known as the "Hollywood 10," and were imprisoned for contempt of Congress (Dmytryk later recanted and named names, saving his career).

Filmmaker and historian Thom Andersen has argued that in the years between the first HUAC hearings in 1947 and the second in 1951, a group of Hollywood leftists, with support from "fellow travelers," responded to the growing climate of political censorship by creating a virtual subgenre of noir. Another way of putting it would be to say there were two branches of the noir "family tree," one tending toward cynicism and misanthropy and the other toward humanism and political engagement. The politically engaged left branch gave a social-realist spin to thrillers, as in Joseph Losey's remake of Fritz Lang's *M* (1950), written in part by the blacklisted

Waldo Salt; and Losey's *The Prowler* (1951), written without credit
by the blacklisted Dalton Trumbo. It called attention to fascism in
American society, as in Jules Dassin's *Brute Force*, written by Richard
Brooks, and John Huston's *Key Largo* (1947), also written by Brooks.
It allowed working-class characters from immigrant groups to
express themselves in dignified form, as in Dassin's *Thieves'
Highway* (1949), which centers on working-class Greeks in the
California trucking industry, and in Abraham Polonsky's *Force of
Evil* (1948), a tragic study of Jews and Italians in the New York
numbers racket. It also made films about racial intolerance,
although it sometimes treated the topic indirectly, as in the
soon-to-be blacklisted Cy Endfield's frighteningly realistic *Try and
Get Me* (1950), which deals with a white mob's lynching of whites.

John Huston's brilliantly shot, edited, and acted *The Asphalt
Jungle* was the most influential of this group of films; never
overtly political, it treated crime as a "left-handed form of human
endeavor" and made the criminal gang far more sympathetic than
representatives of respectable society and the law. Huston's chief
concession to censors was the penultimate scene, in which a
reform-movement police commissioner makes a passionate
speech to reporters: "Suppose we had no police force, no matter
how bad?" he asks rhetorically, and answers, "The jungle wins, the
predatory beasts take over." But the next scene shows the death of
a key figure in the criminal gang—Dix Handley, a simple man of
honor from the country who escapes the law but dies of a gunshot
wound on the pastoral field of a Kentucky horse farm. Dix is
played by Sterling Hayden, a former member of the Communist
Party who, like Huston, was a member of the Hollywood
Committee for the First Amendment. Soon after the film was
released, he reluctantly named names to HUAC.

Alongside the left films, the right branch of noir produced a few
pictures in which the villains were commies, including *I Married
a Communist* (1950, retitled *The Woman on Pier 13*), *I was a
Communist for the FBI* (1951), and *Big Jim McClain* (1952), which

starred John Wayne as an HUAC investigator. As the Red Scare passed and censorship rules began to relax, however, certain dark films were able to look back on the period with anger and irony, notably two films that were indebted to left-wing writer Clifford Odets: Robert Aldrich's *The Big Knife* (1955), one of several movies that made the Hollywood industry seem an ideal setting for noir, and *Sweet Smell of Success*, the story of a Red-baiting gossip columnist modeled on Walter Winchell.

The Manchurian Candidate (1962), which foreshadowed the assassination of John F. Kennedy, marked an end to the worst phase of Cold War hysteria. Skillfully directed by John Frankenheimer and based on a Richard Condon novel that JFK admired, *Candidate* was unavailable for video or DVD viewing for well over a decade because Frank Sinatra, its star and one of its producers, feared it might seem to capitalize on Kennedy's death. In some ways it's a political crazy quilt, but it serves as a satiric reminder of the 1950s zeitgeist, spinning from one mood and narrative convention to another while maintaining a noir-like sense of style. A dream sequence toward the beginning cleverly subverts the continuity principle of Hollywood editing and camera placement; and in a televised news conference later in the picture, TV monitors arrayed around the room are used to counterpoint behind-the-scenes pandemonium with a managed public broadcast. The film's most darkly amusing stroke is to depict a Red-baiting, McCarthy-like senator as the unwitting dupe of the Red Chinese, and the Red Scare itself as a plot managed by spies from Moscow and Peking. All this is controlled on the domestic level by a seductive matriarch (Angela Lansbury) who gives her son (Laurence Harvey) the kiss of death, turning him into a zombified, murderous sissy.

The other side of town

Much could be written (and has been) about the cultural politics of film noir, which has been affected not only by such official

agencies as the PCA, but also, more indirectly, by the general culture's treatment of women and minorities. One reason noir is interesting from this perspective is that it has so many "in-between" or mixed qualities: it occupies a liminal space between art and potboilers; it involves both action pictures and "women's" melodramas; it often centers on a zone between the law and the underworld; and its action keeps moving back and forth between respectable and disreputable areas of town, bringing together people of different status. (As art-dealer Clifton Webb remarks in *The Dark Corner*, the fancy parties he gives are "a nauseating mixture of Park Avenue and Broadway.") Sometimes—most conspicuously in *Touch of Evil*—it involves crossing and re-crossing actual borders. Aside from frontier westerns about cowboys and Indians, it offers middle-class white audiences their most frequent opportunity to see "others": sexually independent women, homosexuals, Asians, Latins, and blacks.

Feminist film critics and theorists share no single position on the sexual politics of noir, in part because many classic examples displace the patriarchal family in favor of lone wolves and spider women. Although the noir femme fatale has origins in male fears of modern women, and although she usually comes to a bad end, she nevertheless remains a threat to the proper order of things and does what E. Ann Kaplan describes as important "ideological work." Some of this work is made explicit in *The Big Heat*, when gangster's moll Gloria Grahame confronts the widow of a police chief, describing herself and her apparent opposite as "sisters under the mink." Many noir films in the 1940s try to contrast the tough, sexy bad girl with the housewife and mother or the virginal innocent (examples can be seen in *Double Indemnity*, *The Big Heat*, and *Out of the Past*), but the bad girl is always the most fascinating character. Certain of the films play with this good/bad distinction in interesting and potentially subversive ways: see especially *Pitfall* (1948) and *The Narrow Margin* (1952). Notice also that certain noir-like women's melodramas undercut the formula for what Hollywood once called "women's weepies."

R. Barton Palmer has pointed out that *Possessed* and *Cause for Alarm* (1947) differ from a non-noir melodrama such as *Now, Voyager* (1942) because they don't offer a "compromised yet satisfying wish fulfillment—that is, the heroine put back in her place but offered a different, rewarding life."

An equally mixed set of responses can be found in discussions of noir masculinity and homosexuality. Although the Production Code of the 1940s explicitly forbade the depiction of homosexuality, the repressed returned in various ways. The tough, masculine novels of Hammett and Chandler had latently homosexual characters that were transposed into the films. Sometimes homosexuality was stereotyped, as in Bogart's imitation of a lisping bibliophile in *The Big Sleep*, but more often the villains were subtly portrayed as homosexual, as in *The Maltese Falcon*, *Rope* (1948), *The Big Heat*, and *Strangers on a Train*. One of the more curious instances of the murderous queer is *Laura*, in which Clifton Webb plays Waldo Lydecker as an effeminate, Wildean aesthete, while the plot works hard to tell us that he's a jealous heterosexual with a Pygmalion complex. Given these many examples, Richard Dyer has remarked that film noir "abounds in colorful representations of decadence, perversion, aberration, etc.," and that it expresses "a certain anxiety over the existence and definition of masculinity and normality."

The sexual politics of noir are further complicated because female, lesbian, and homosexual artists have contributed to the films. As we've seen, women provided the sources and screenplays for key examples of noir. Cornell Woolrich was homosexual and Patricia Highsmith was lesbian. The only important woman director in Hollywood during the 1940s and 1950s was Ida Lupino, who was responsible for *The Hitch-Hiker* (1953) and *The Bigamist* (1953). In the later 20th century, women directors made exceptional films involving noir themes or plots: Barbara Loden's *Wanda* (1971), an unromantic, love-on-the-run movie like no other; Bette Gordon's *Variety* (1983), an equally unromantic treatment of *Vertigo*-like obsession involving a female protagonist who works as a cashier at

a porn movie theater (1958), and Maggie Greenwald's *Kill-Off* (1990), an excellent adaptation of a Jim Thompson novel.

Racial representations in Hollywood film noir are an equally mixed bag. Judging purely from the titles of many of the films (*The Lady from Shanghai* (1947), *Macao* (1952), *The Manchurian Candidate*, *Chinatown* (1974), etc.), noir might seem linked to the Far East—an interest that dates to the orientalist motifs in Hammett and Chandler, whose writings involve everything from Tong wars to sultry Asian females like the one in Chandler's *The High Window*, who has "eyes like strange sins." Throughout World War II, Hollywood depicted the Japanese with racist stereotypes, but after the war Samuel Fuller made *The Crimson Kimono* (1959), a noir police thriller sympathetic to Japanese Americans, which ends with an inter-racial kiss. Later, *Chinatown* used orientalist motifs ironically, treating them as a white projection.

Latin America appears in classic Hollywood noir even more often than Asia, partly because of its proximity to California and because during World War II the US "Good Neighbor Policy" encouraged films with Latin settings or characters. It takes a variety of forms, from the sleazy border towns in *Where Danger Lives* (1950) and *Touch of Evil* to the luxurious cities in *Notorious* (1946) and *Gilda*. Sometimes it hovers around the edges of the plot, as in *Double Indemnity*, when Phyllis Dietrichson tells Walter Neff that she bought her perfume in Ensenada. It's frequently associated with romance and escape, offering a countervailing warmth to the dark mise-en-scène and emotional coldness of the characters. In *Raw Deal* (1948), Joe Sullivan tries to escape to Panama; in Robert Towne's original screenplay for *Chinatown*, Jake Gittes and Evelyn Mulwray were supposed to escape to Mexico; and in *Out of the Past*, the passionate romance between Jeff and Kathie develops against the background of a Mexican town with "a nice little cantina down the street called Pablo's." (*The Lady from Shanghai* treats

this romantic trope critically, making the resorts of Acapulco look like what Michael O'Hara calls a "bright, guilty world.")

When Anglo characters went south of the border, they usually took their neuroses with them, and Hollywood's vision of Latin America was largely confined to a mélange of sentimental pastoralism and chic nightclubs. Welles's *The Lady from Shanghai* and *Touch of Evil* are exceptions to the rule because they show rich northerners using the Latin world as a kind of brothel and give brief glimpses of poverty on the Mexican streets. Mexican characters in other classic noirs are mostly seen as strolling peasants or bumbling cops; one exception is *Border Incident*, in which Ricardo Montalban plays an undercover agent trying to stop Anglo smugglers and murderers of immigrants. Ironically, several of the classic films were made during a period of racial tension in Latin communities of Los Angeles; the notorious 1943 "Sleepy Lagoon" case, in which a group of Chicanos were framed for the murder of an Anglo couple, indirectly influenced the post-war social-realist thriller *The Lawless* (1950), which changes the locale from the city to a small agricultural community. Beginning around 1960, however, the population of LA, which had the largest concentration of white protestants in the country, began to shift toward Latino and Chicano Catholics, and this affected films. In its pre-release version, the dystopian noir *Blade Runner* (1982), which is set in LA's Chinatown and seems ambivalent about "hybrids" and aliens, has a sympathetic Chicano character who functions as a sign of population change.

Film noir has never been translated as "black film," probably because the French term sounds romantic and because an English translation might seem to refer to African-American cinema. For most of the Hollywood studio period, blacks were almost invisible, appearing only in musical numbers or brief scenes involving Pullman porters, servants, and comic scaredy-cats like Stepin Fetchit. Raymond Chandler's novel *Farewell, My Lovely* begins in the black district of south central Los Angeles, but when the novel

was adapted as *Murder, My Sweet*, the setting was changed to a white working-class area. Black novelists Richard Wright and Chester Himes were intensely concerned with murder and mean streets—Himes, in fact, was an important contributor to Gallimard's *Série noir*—but neither was adapted by classic Hollywood. When Orson Welles first came to RKO, he planned to film an updated, anti-fascist version of Conrad's proto-noir *Heart of Darkness*; the studio cancelled the project, in part because it dealt with miscegenation and Welles wanted to hire lots of black extras.

In movies of the period, black performers were seldom shown in close ups unless they were musicians playing jazz, as in *D.O.A.* (1949). Rarely were they humanized. A brief exception to the rule is a short scene in *Out of the Past*, when private eye Robert Mitchum visits a black nightclub to question a maid played by Theresa Harris, who had worked with the film's director, Jacques Tourneur, in Val Lewton's horror films. A fully developed black character doesn't emerge until the independently produced *Odds Against Tomorrow* (1959), a heist film written by blacklisted Abraham Polonsky and "fronted" by black writer John O. Killens. This film involves a group of bank robbers, one of them a white southern racist and another a black jazz musician. The robbery fails, leading to a gun battle between the white and the black at an oil refinery. When an oil tank explodes, it leaves nothing but the charred bodies of the two men. An investigating fireman asks, "Which is which?"

In the 1970s, with the fall of the old PCA censorship rules and the qualified victory of the Civil Rights movement, a cycle of crime films featured black actors, and a few were directed by blacks. Richard Roundtree stars in Gordon Parks's *Shaft* (1971), playing a super-stud private eye ("I'm not James Bond, I'm Sam Spade."). The black criminal protagonist of Melvin Van Peebles's *Sweet Sweetback's Baadasssss Song* (1971) fulfills every nightmare of white society and emerges unconquered. By the 1990s, the urban thriller frequently involved black characters. The director most influenced by this

development was Quentin Tarantino, whose *Pulp Fiction* (1994) uses the n-word even more often than "bitch," and tries to establish Tarantino as what Norman Mailer once naively described as a "white negro." (John Travolta and Samuel L. Jackson play a team of hit men, Bruce Willis saves a black from being raped by southern racists, and Tarantino appears as a suburban gangster married to a black woman.) More recently, Ridley Scott's noir-like *American Gangster* (2007) stars Denzel Washington as real-life New York drug lord Frank Lucas, a villain ultimately brought down by the police.

One problem of this later group of crime movies is that they perpetuate what black filmmaker Charles Burnett has called "Myths about black people... action-packed dramas about drugs and so forth." In response, Burnett wrote and directed one of the best crime films about blacks, *The Glass Shield* (1994). Free of sex scenes, sparing of violence, and loosely based on actual events, it concerns a Los Angeles sheriff's station where racist officers have murdered black prisoners, blackmailed white suspects, and conspired with the District Attorney's office to frame a black man for murder. Much of the action, some of it photographed in expressionist color, is viewed from the perspective of an idealistic but callow black officer whose commitment to a police career causes him to repress his identity and betray his community.

An equally good film noir directed by a black is Carl Franklin's *Devil in a Blue Dress* (1995), starring Denzel Washington and based on the Walter Mosley novel. Like *One False Move* (1992), Franklin's previous film noir, it has lean, suspenseful action sequences reminiscent of Hawks and Mann. Set in 1948 Los Angeles, it's clearly indebted to Raymond Chandler and classic private eye movies, but because the action is viewed from a different social, economic, and racial perspective, familiar motifs of urban film noir are neatly reversed. The dance clubs and pool halls along Central Avenue are shadowy and sometimes violent (especially when whites invade them), but far more

accommodating than Santa Monica Pier or the Ambassador Hotel, where black private eye Easy Rawlins must pursue his investigation. Beautifully orchestrated crane shots on Central Avenue show a vibrant social life. At the Regent Theater, we glimpse a marquee advertising the early black independent filmmaker Oscar Micheaux's last film, *The Betrayal* (1948), and inside the dance clubs we find that post-war, black Los Angeles was a center not so much of jazz as of early rhythm and blues. The white world beyond is dangerously alien territory, and poor and semi-rural areas are given peace and dignity. As Paul Arthur has put it, "the white districts and their bases of individual and institutional domination...serve as the heart of darkness."

The film also reverses the convention of the femme fatale, in the process commenting on racial passing and what the 1940s regarded as "the tragic mulatta." Like Velma Valento in *Murder, My Sweet*, Daphne Monet (Jennifer Beals) conceals her identity by heightening signifiers of social class, but she also conceals signifiers of race. The scene in which Rawlins confronts her and discovers her history is ironically similar to a key scene in *Chinatown* (to which *Devil*'s photography, music, and design are indebted). As in the earlier film, the putative femme fatale is revealed to be a victim. But although the film ends tragically for Daphne, Rawlins isn't crushed or alienated by the evil he uncovers. At the conclusion, he walks confidently down the street in front of the small, tidy house he owns, smiling at his neighbors and their children.

Chapter 4
Money, critics, and the art of noir

As Andrew Sarris once wrote, "A disproportionate number of fondly remembered B pictures fall into the general category of the *film noir*...somehow, even mediocrity can become majestic when it is coupled with death." But there are added reasons why many films in the category are called—not always accurately—B pictures. The label "noir" took root in America in the 1960s and 1970s, when vintage examples, often seeming cheap in the eyes of a young audience because they were in black and white rather than color, were exhibited in revival houses or college-town theaters alongside European imports. Godard's *Breathless*, one of the most influential art movies of the 1960s, was a homage to noir dedicated to Monogram Pictures, a defunct Hollywood studio that specialized in B-budget productions. Godard shot the film on the streets of Paris using high-speed, relatively expensive black and white that muted contrasts, and photographer Raoul Coutard executed tracking shots with a wheelchair, creating an "imperfect" style that connoted a spirit of poverty.

Meanwhile, cinephilia was nurtured in the bohemian atmosphere of alternative newspapers and small journals, where aficionados tended to praise pulpish genre movies. It became hip to prefer the cheapo *Murder is My Beat* (1955) to *The Maltese Falcon*, or *Touch of Evil* to *Citizen Kane*. Hard-boiled pictures such as Monogram's *Decoy* (1946) and PRC's *Railroaded* (1947) were increasingly

exhibited (and still play well) on the late show and as midnight movies in theatres, giving atmosphere and adventure to the naked city. The cheapness of such films was one reason sophisticated critics praised them. B-movie noir seemed to fly under the radar of the culture industry, uncontaminated by spectacle and big studio promotion; low economic value sometimes became high artistic value.

Sarris wryly observed that he and the other auteurists were "vulnerable to the charge of preferring trash to art," and to "employing the classic highbrow gambit of elevating low-brow art at the expense of middle-brow art." The critic most representative of the new sensibility, however, was Manny Farber, who never used the term film noir but increased interest in what he called "termite art" as opposed to "white elephant art." Farber's influential 1957 essay, "Underground Cinema," celebrates "faceless movies, taken from a kind of half-polished trash writing...A stool pigeon gurgling with scissors in his back;...an underpaid shamus signing up to stop the blackmailing of a tough millionaire's depraved thumb-sucking daughter." Never mind that *The Big Sleep*, one of the films Farber describes, was adapted from a highly polished novel by Raymond Chandler, that one of its screenwriters was William Faulkner, and that it used all the production resources of Warner Bros. Farber made it seem "underground," suitable for viewing in a fleapit theater where "the broken seats are only a minor annoyance."

No matter what the production circumstances, a feeling of low economic circumstances was visually inscribed in big studio dramas about private eyes who live in cheap apartments and battered offices. Partly for that reason, the more expensive noirs of the 1940s could be imitated at minor-league studios or at the low-rent organizations located on what was known as "Poverty Row." Roy William Neill's modestly produced *Black Angel* from Universal Pictures is almost as enjoyable as *The Big Sleep*, and William Castle's even cheaper Monogram thriller *When Strangers Marry* (1944)

received high praise from both Manny Farber and Orson Welles. Producer Val Lewton's low-budget, noir-like horror films from RKO played in bargain-basement theaters and were deservedly admired by critics; even so, RKO's chief executive, Charles Korner, grumbled that Lewton's *Cat People* was seen only by "Negros and defense workers."

Until the late 1940s, when box-office receipts declined and the vertically integrated studio system began to die, there was a stable marketplace for low-budget thrillers. (It was also an era rich in low-budget westerns.) The B-picture designation had originated during the Great Depression, when Hollywood tried to lure audiences with double features, offering two pictures for the price of one; the second or "B" feature wasn't necessarily cheap, but was thought to have less box-office appeal and was rented by exhibitors at a lower rate. Eventually, the term came to mean genre films with low production values shown in venues outside the orbit of the big-studio theater chains. By the 1960s, it no longer applied. Cheaply made "exploitation pictures" played drive-ins (an example is shown in Bogdanovich's *Targets*), but few conformed to the old generic formulas.

Between 1940 and 1950, when production costs and ticket prices rose almost 60 percent, the average Saturday-matinee western from Poverty Row cost about $50,000, and B pictures from such Poverty-Row studios as Republic, Monogram, and Producers Releasing Corporation (PRC) were typically held to budgets under $200,000. In the previous decade, John Ford's non-film noir *The Informer* (1935), budgeted at $243,000, was sometimes erroneously described as a B picture, but was an "intermediate" production that premiered at Radio City, received gilt-edged marketing, and won Academy Awards. Several of the best films later designated by critics as B-movie noir were intermediates with wide distribution and good publicity. A case in point is *T-Men* (1947), distributed by Eagle-Lion Pictures and shot at PRC for $450,000. Directed by Anthony Mann and photographed by noir master John Alton,

T-Men received high praise in *Life* and *Newsweek* and grossed $1.6 million—a profit that would have been impossible under the usual B-picture rental rates for exhibitors. Much the same could be said of Joseph H. Lewis's three relatively inexpensive and excellent noirs, *My Name is Julia Ross* (1946), *Gun Crazy*, and *The Big Combo* (1955). On the grounds of these pictures, Lewis has often been described as a B-movie auteur; but even though he made a few very low-budget comedies at Monogram and westerns at PRC, his film noirs were mid-level productions.

For a truly cheap noir of the classic period, one needs to view Cy Endfield's *The Argyle Secrets* (1948), which was budgeted at $125,000 and distributed by Film Classics. Derived from a radio drama, it has a running time of an hour and ten minutes and its sets and photography are on a par with the average Saturday matinee. Nevertheless, it moves swiftly and manages to borrow ideas from *Citizen Kane*, *The Maltese Falcon*, and *The 39 Steps*, meanwhile offering tough offscreen narration, a dreamlike montage in which the protagonist is beaten and tortured by gangsters, and many dark twists and ironies. It was barely reviewed and tended to play on the bottom half of double bills.

The most impressive director of authentically low-budget noir was Edgar G. Ulmer, a German émigré who had worked with Murnau, Lang, and Lubitsch, but who spent most of his career at the lowest levels of the Hollywood industry. Andrew Sarris observed that movie artists "don't come any more *maudit*." Ulmer's masterpiece, *Detour* (1945; Figure 8), was shot in one week at PRC for the cost of $117,226.80; it runs a bit over an hour, has no stars, and was described by *Variety* as "okay as a supporting dualer." Contemporary with the first group of films the French termed American noir, it can stand comparison with any of them, and in my opinion is among the best films of the type ever made.

The *Detour* screenplay, credited to Martin Goldsmith and based on one of his novels, was much condensed by Ulmer, who retained

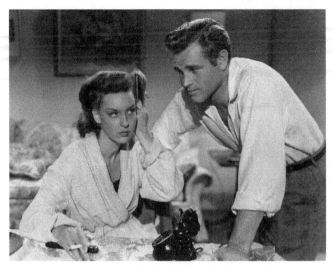

8. Tom Neal and Ann Savage in *Detour* (1945).

its James M. Cain-like atmosphere while giving the story an
uncanny, twist-of-fate quality similar to Cornell Woolrich and 1940s
radio dramas. In the first scene, protagonist Al Roberts (Tom Neal),
wearing a rumpled suit and in need of a shave, drinks coffee alone
at a roadside diner outside Reno, Nevada. A truck driver puts a coin
in a juke box and we hear the opening strains of "I Can't Believe
that You're in Love with Me." Al's offscreen voice asks, "Why was it
always that rotten tune?" As he broods over his coffee, his inner
voice takes over (more than half the words in the film are his
narration), and a flashback shows him in somewhat better days,
as a frustrated classical pianist working with a jazz combo in a
Greenwich Village nightclub, where his girlfriend Sue (Claudia
Drake) is lead singer. When Sue moves to Los Angeles in hopes
of a movie contract, Al sinks into a black mood and decides to
hitchhike across country and join her.

After long, brutal days on the road, Al gets a ride in a flashy
convertible with a man named Haskell (Edmund MacDonald),

who has a badly scratched hand. That night, Haskell becomes mysteriously ill and dies. Al fears that he will be accused of murder, so he hides the body and temporarily assumes the dead man's identity. As he goes further down the road in Haskell's car, he picks up a tough, bedraggled, sexually provocative hitchhiker named Vera (Ann Savage), who tells him she was responsible for the scratch on Haskell's hand. Vera threatens to expose Al unless he sells the car and gives her half the money. When the couple arrive in Los Angeles, she learns that Haskell (who turns out to have been a "hymnal salesman") was the heir of a dying millionaire, and insists that Al continue the masquerade. They spend the night in rented rooms, drinking heavily and quarreling over Vera's scheme. Ultimately she picks up a telephone and runs into the bedroom, locking the door and threatening to call the police. Al grabs the telephone cord and pulls it hard. When he breaks into the bedroom, he finds Vera dead, the cord tangled around her neck.

Al is an unreliable, self-pitying narrator who blames his troubles on fate, and the film depicts his westward journey across America as a trip through a wasteland, its open road a meaningless circle or trap. Much of the imagery anticipates *Psycho*: a protagonist who drives day and night, staring into a rear-view mirror and hearing voices from the past; a sinister highway patrol officer with dark glasses; and a cheap and deadly rented room. Ulmer lacks the technical facilities of A-list directors, but he works cleverly with the minimum of resources. He creates an enlarged, fake coffee cup for an eerie closeup in the diner scene, he represents New York with a single street lamp on a foggy studio set, and he renders Los Angeles with a used car lot and a drive-in restaurant. He makes expressive use of old-fashioned optical devices such as wipes and irises, and he's the only Hollywood director beside Welles to deliberately exploit the artificiality of back projection (see the enlarged fence posts or guard rails that stream by the windows of Haskell's car as he and Al drive by night).

Occasional technical glitches give *Detour* an uncommercial aura and make the average film noir look overly slick. The flimsy sets reinforce the theme of impoverishment and the actors seem as marginal as the characters they play. Nowhere is this last quality more apparent than in Ann Savage's performance as Vera. Savage's birth name was Bernice Maxine Lyon, but no actor had a more appropriate *nom de cinéma*. Shortly before her death, Guy Maddin cast her as his mother in the quasi-autobiographical *My Winnipeg* (2009), and praised her role in *Detour* for being "as much ferally attacked as performed." She makes every other femme fatale in movie history look genteel. Al compares her with Camille because she has dark rings around her eyes and a consumptive cough, but she's no sentimental heroine; ruthlessly hard and half crazed, she lolls around the Los Angeles rooms in a bathrobe, downing straight whiskey, chain smoking, alternately insulting Al and inviting him to bed. Sullen, dangerous, yet somehow sympathetic, she probably knows she's dying. It's impossible to imagine any A-budget picture that would have been allowed to depict her.

By 1955, the B-picture industry that could support a production like *Detour* had ended, but a few films in the late 1950s prefigured the development of independently produced, low-budget thrillers that would appeal to the emerging art-cinema market. Stanley Kubrick's self-produced *Killer's Kiss* (1955), the perverse story of a sexual triangle between a gangster, a dance-hall girl, and a prize fighter, was made so cheaply that it has almost no direct sound or dialog. The opening scenes borrow imagery from Kubrick's short documentary *Day of the Fight* (1951), and later scenes in New York's Times Square were shot with a hidden camera. The cost-cutting creates oneiric or abstract effects, as when a flashback within a flashback shows a ballerina dancing against a black limbo. Several impressive sequences employ New York School street photography (in which the young Kubrick was well versed) and the climactic battle between the gangster and the prize fighter, staged in a mannequin factory, rivals the mirror maze in Welles's *Lady from Shanghai* for grotesque, surrealistic inventiveness. (Welles

directed his own relatively low-budget thriller in 1955: *Mr. Arkadin*, released in the United States ahead of the art-movie distribution system that might have made it successful.)

One of the best noirs of the period, Irving Lerner's *Murder by Contract* (1958), shot in only a week, received favorable reviews and would go on to influence Scorsese's *Taxi Driver*. A dead-pan, blackly comic film, it stars Vince Edwards as a professional hit man who wants to make enough money to buy a house on the Ohio river. The dour, misogynistic, emotionally repressed killer waits alone in drab hotel rooms for assignments, balancing his bank book and doing pushups and sit-ups. Eventually the Mob sends him to Los Angeles, where he's supposed to assassinate a female witness in an upcoming trial. "If I'd known it was a woman," he says, "I would have asked double... It's tough to kill someone who's not dependable." When he visits an LA gun shop, he remarks to one of his handlers that the place is "crazy" because it doesn't sell anti-tank guns. "To get that gun you have to be a civilized country," the gangster says. "Are you a civilized country?" Ironically, when the hit man tries to carry out his elaborately planned job, he needs to crawl through a large drainage pipe, which in context looks symbolic of a woman's birth canal.

From the 1970s onward, low- and intermediate-budget noirs became increasingly allusive, acknowledging their artistic influences and finding audiences in art theaters. Martin Scorsese's *Mean Streets* (1973) quotes *The Big Heat* and borrows camera techniques from Godard and Truffaut; the Coen brothers' *Blood Simple* (1984) takes its title from Hammett and uses a Steadicam to create hyper-Wellesian tracking shots; Neil Jordan's *The Crying Game* (1992) alludes to *Mr. Arkadin*; and Quentin Tarantino's *Reservoir Dogs* (1992) nods to Kubrick, Godard, and a host of others. Perhaps as a result of the recognition and critical prestige these films obtained, noir in the 1990s tended to oscillate between star-laden productions (Paul Verhoeven's *Basic Instinct* (1992); Scorsese's *GoodFellas* (1990) and *Casino* (1995); David Fincher's *Se7en* (1995); Michael Mann's *Heat* (1996)) and inexpensive pictures such

as Steven Soderbergh's *Underneath* (1994), which was a remake of Robert Siodmak's *Criss Cross* (1949), and John Dahl's *The Last Seduction* (1995), which was initially intended for cable TV.

In the 1990s, direct-to-video (DTV) and cable TV became prime sources of low- to intermediate-budget films. When video stores still existed and theatrical pictures were often budgeted at eighty million dollars, DTVs grew to a seventeen-million-dollar a year industry, fueled by soft-core "erotic thrillers" that were inspired by the box-office success of *Basic Instinct* and *Fatal Attraction* (1987) and cost roughly a million. Cable TV followed suit, producing "cable noir" series such as Showtime's *Fallen Angels* (1993–5). Today, streaming networks are laden with intermediate-level noir features or mini-series; as one example, consider the British–Irish production of *The Fall* (2013–16), starring Gillian Anderson as a police detective with almost as many psychological problems as the serial killer she investigates.

In today's world of extravagant budgets for theatrical distribution, intense action thrillers such as Jaume Collet-Serra's *Non-Stop* (2014) or comic heist films such as Steven Soderbergh's *Logan Lucky* are produced for fifty million dollars and up. But as David Bordwell has pointed out, noir-like thrillers with more intermediate-level budgets and name directors have become regular features at international film festivals and in the art-cinema market, often garnering high critical praise and awards. The cost of Asian and European noirs is difficult to obtain, but Johnnie To's *Mad Detective* (Hong Kong, 2007) or Christian Petzold's *Jerichow* (Germany, 2008) were far less expensive than the average Hollywood picture. To these titles could be added Bryan Singer's *The Usual Suspects* (1995), Christopher Nolan's *Memento* (Australia, 2000), Sidney Lumet's *Before the Devil Knows You're Dead* (2007), and David McKenzie's *Hell or High Water* (2016), which are all excellent examples of "intermediate" noir. Only the low- to medium-budget horror film (in some ways a cousin to noir) appears as frequently in today's spectacular, superhero-dominated marketplace.

But economics is not the only determinant of the many intermediate-level noirs. Bordwell, in discussing a larger category of what he calls "thrillers," offers a couple of other plausible reasons. First, over the past few decades, crime literature has become more widely publicized and critically legitimate. Regardless how much literary value one might attribute to Lee Child, Michael Connolly, and John Gresham, they're well-reviewed authors who regularly appear on best-seller lists and are occasionally turned into high-end movies; meanwhile, the runaway success of dark, female-centered crime novels has led to movie adaptations of Stieg Larsson's *The Girl with the Dragon Tattoo* (Sweden, 2009 and US, 2011), Gillian Flynn's *Gone Girl* (2014), and Paula Hawkins's *The Girl on the Train* (2016).

Second, and perhaps more important where budgets are concerned, noir-like variations of the thriller are among the most "stylish" of cinematic forms. Film noir tends to involve not only intricate plotting but also visual and aural effects that make artfulness more evident and more attractive to the art-theater market. (I would add that it often denies us the gratifications of conventional melodrama—justice triumphant and the world restored—and for that reason critics tend to regard it as more artistically truthful.) Even though it's seldom among the biggest box-office hits, it has formulaic qualities that qualify as entertainment, it can be relatively cheap to produce, and it can boost the reputation of directors because its appeal is strongly rooted in style.

Chapter 5
Styles of film noir

One way of defining "style" is to say that it's the way individuals play within the rules of a game. In tennis, for example, the rules are fixed, but Nadal doesn't play quite the same way as Federer. When we move from sport to art, the rules are less fixed and the possibilities for individual expressiveness greater. Art also has more period or group styles, and more ability to change the rules, as when the cubists and the abstract expressionists abandoned realistic easel painting.

Where motion pictures are concerned, the quasi-industrial basis of production and the many arts it involves complicate discussion of style. In the 1940s, at the height of what later became known as film noir, there were small armies of craft workers at the Hollywood studios and uncodified but relatively fixed rules or conventions that applied to every aspect of feature films. The major directors played the movie game in slightly different ways: certain noir directors (Orson Welles, John Farrow, Max Ophuls) favored long takes and moved the camera a great deal; others (John Huston, Edward Dmytryk) relied on cutting between dynamic compositions; still others (especially Howard Hawks) were almost invisible storytellers who avoided directorial flourishes. Each of the studios also had something of its own style because of the photographers, designers, and musical

composers it employed. The same could be said for the studios of other national cinemas.

Contrary to what has sometimes been said, there never was a single narrative or visual style of film noir, even in the 1940s. Noir in the classic period is commonly associated with black-and-white photography, flashbacks, voice-over narration, unbalanced compositions, vertiginous camera angles, deep focus, and night-for-night exteriors (scenes shot on location at night using flood lights, with characters visible against a black sky). But only a few of those things can be found in a certifiable noir classic such as Hawks's *The Big Sleep*, which was shot entirely in a studio with the camera at eye level. Far more can be found in David Lean's *Brief Encounter* (Britain, 1945), a romantic melodrama that nobody would call a film noir. Every kind of film in the 1940s, including musicals and comedies, used flashbacks, dream sequences, and offscreen narration. Psychoanalysis was in vogue, and because characters suffered from neurosis or quasi-Freudian obsessions, flashbacks were common in various sorts of movies. (Reviewing *Double Indemnity* for *The Los Angeles Times* on October 10, 1944, Phillip K. Scheuer complained, "I'm sick of flashback narration and I can't forgive it here.") Amnesia plots involving flashbacks, like the ones in such noir pictures as *Somewhere in the Night* (1946), *The Chase*, and *The Crack-Up* (1946), were rife, and could be seen in films that don't qualify as noir, starting with the hit romance *Random Harvest* (1942). In Rex Stout's 1947 detective novel *Too Many Women*, Archie Goodwin returns to Nero Wolf's office after seeing a movie and says it was "wonderful" because "only two people in it have amnesia."

Photographically speaking, as lighting historian Patrick Keating has observed, classic film noirs were as stylistically heterogeneous as any other kind of picture: "There were studio noirs and location noirs; soft-focus noirs and deep focus noirs; grey noirs and black noirs." We can nevertheless speak of an overarching period style (or styles) in the 1940s, determined by everything from

censorship regulations and available technology to conventions in narrative, genres, costumes, and photographic lighting. The classic film noirs, a subset of the period style, were governed by a generally agreed upon "mysterious" look and could be understood in terms of what Geoffrey O'Brien calls "a nexus of fashions in hair, fashions in lighting, fashions in interior decorating, fashions in motivation, fashions in repartee." But over the next decade, the studio system was reconfigured, new technologies emerged, and entertainment diversified; whole cities in America were transformed, shifting from what Edward Dimendberg calls "centripetal" to "centrifugal" spaces, dotted with strip malls. Movie fashions and modes of production changed along with the rest of the world, leading to other period styles. Film noir has persisted, but it doesn't look the same in different periods.

Some directors have continued to favor camera movement, but today's movement, which is facilitated by Steadicams, is far more spectacular, offering the possibility of single shots that last for hours. Digital editing increases the speed and variety of montage sequences, Digital-Intermediate (DI) allows for "retouching" of images in post-production, and Computer-Generated Imagery (CGI) replaces the old techniques for special effects. Like the old pictures, 21st-century noirs use continuity editing (editing that makes the temporal and spatial continuity between shots smooth and clear), but digital technology has led to what David Bordwell calls "intensified" continuity, involving quick cutting between large closeups. Big-budget directors shoot with multiple cameras and wireless microphones attached to actors, and create sequences that shorten the average shot length; most shots, especially in action movies, are held on the screen for somewhere between two and eight seconds. In Tony Scott's *Man on Fire* (2004), every blink of an eye, every drag on a cigarette, every swig of booze, and every gunshot gets a closeup; the same is true of David Leitch's *Atomic Blonde* (2017), which has dynamic, rapidly edited fight sequences and car chases that would have been impossible under the technical conditions of classic noir.

For shots of longer duration, the new noir uses a Steadicam camera mount that facilitates "walk and talk" scenes along corridors and 360-degree turns around characters. Noirs also use CGI. In Matthew Vaughn's *Layer Cake* (2005), the drug dealer played by Daniel Craig walks into a pharmacy and fantasizes about the day when all drugs will be legal: the camera glides along with him as he moves past imaginary bottles of ecstasy and cocaine that line the shelves, but as he walks in a 180-degree arc the bottles morph into the "reality" of ordinary products.

Like every other kind of entertainment film in the current marketplace, noir continues to follow the old formula of goal-driven, conflict-induced, cause–effect narratives in which problems or enigmas are resolved by the last scenes. Noir occasionally tests the limits of the formula without deconstructing it: Christopher Nolan's *Memento* tells the story backwards and keeps throwing the audience off balance, and Alan Coulter's *Hollywoodland* (2006) has a *Rashomon* structure that leaves unanswered the question of whether a violent death was murder or suicide. Noir still sometimes employs flashbacks, but they can be less strongly marked by dissolves or offscreen narration, as in Barnaby Southcombe's *I, Anna* (2012), which requires the audience to do a bit more work distinguishing between past and present.

One of the major differences between old noir and new noir, at least in qualitative terms, has been a change from standardized censorship codes to a ratings system that allows for graphic sex and violence. But another major difference has been the shift from black and white to color, about which more needs to be said.

Black and white and color

From the beginning of motion pictures until the mid-1950s, most professional photography, whether in movies, newspapers, magazines, television, or family portraits, was in black and white.

By 1940, the technology of color was well advanced: John Ford's award-winning documentary *The Battle of Midway* (1943) was shot in 16 mm Kodachrome, a format often used in home movies. Despite this, and despite the success of David Selznick's *Gone with the Wind* (1939) and Laurence Olivier's *Henry V* (Britain, 1945), the Hollywood studios regarded the Technicolor process—an industry standard, requiring a special camera—as too expensive and commercially unproven for most feature films. Color was confined mostly to animation, travelogues, and musicals—the "cinema of attractions" as opposed to the cinema of realism. Even big-budget westerns such as *Yellow Sky* (1948) and historical pageants such as *The Prince of Foxes* (1949) were photographed in black and white, which was thought more appropriate to dramatic subjects.

If black and white was associated with dramatic realism, it also, paradoxically, had rarified aesthetic value in the world of fine art. Sculptor Louise Nevelson, who worked at the same time as classic film noir, described black as "the most aristocratic of colors." Her contemporary, the abstract-expressionist painter Ad Reinhardt, praised black as essentially "aesthetic," unlike red or yellow, which had to do with "vulgarity or folk art or something like that." During that same period, the center of international modernism shifted from Paris to New York, a city increasingly identified with black-and-white imagery. "As a native New Yorker," artist Richard Kostelanetz remarked, "two colors are worthy of art—black and white; all other colors are appropriate for illustrations." Black-and-white cityscapes became synonymous with urban art photography, and a generation of New York street photographers fused realism and aestheticism. Their work influenced such noir movies as *The Naked City* and *The Window*, and in combination with the post-World War II turn away from filming on studio stages, helped foster a decade of what R. Barton Palmer has described as "noir semi-documentaries." The trend began with 20th-Century Fox's *House on 92nd Street* (1945) and continued with the same studio's *Boomerang* (1947)

and *Call Northside-777* (1948), eventually leading to powerful, minor-studio crime exposés such as *The Phenix City Story* (1955). Although the hard-boiled fiction that inspired classic film noirs had originated in pulp magazines with vivid color covers, the best film adaptations from 1941 until the mid-1950s, whether in studios or on the streets, gave it a sense of realism and an art by means of a more chromatically limited and abstract visual form.

The most celebrated of the noir cinematographers of the 1940s, and the one who most exemplified the mix of realism and aestheticism, was John Alton, who was given special praise in Paul Schrader's seminal "Notes on Film Noir." Although Alton worked on other kinds of film (he photographed the frightening yet funny black-and-white nightmare in Minnelli's *Father of the Bride* (1950) and the Technicolor ballet in Minnelli's *An American in Paris* (1951)), his film noirs are outstanding examples of what Schrader describes as a tendency toward stylistic "mannerism."

A Hungarian emigrant who spent several years working on films in Argentina, Alton had become a Hollywood photographer in 1939, largely at Poverty Row studios. Like many of his generation, he was influenced by the extreme depth of field, wide-angle lenses, tilted angles, and dramatic lighting in *Citizen Kane*, and his many crime films gave him the chance to exploit those techniques to their fullest. In 1949, he published a sort of textbook entitled *Painting with Light* (reprinted 1995), which is surprisingly conventional when compared with the remarkable effects he created on screen. His several noir collaborations with director Anthony Mann (*T-Men*, *Raw Deal*, *He Walked by Night* (1948), *Reign of Terror*, and *Border Incident*) have a visual "signature" that owes more to him than to the director.

A Sternberg-like dandy rather than a tough guy, Alton was unusually sensitive to light, shadow, and tonal variation: lacy or barred shadows on faces or walls; light beaming through clammy

fog; glistening light on wet streets; areas of light in total blackness; "Jimmy Valentine" lighting from below that makes figures look menacing (named for the legendary safe-cracker who put his flashlight on the floor while turning a combination lock); and soft glamor lighting of women, which involved a special light to make their eyes gleam. He also positioned his camera at odd angles and created bizarre perspectives by manipulating the focal length of the lens. In *T-Men*, a film that depended a good deal on location shooting, two characters in a darkened room have a conversation over a lighted lamp; Alton uses a wide-angle lens and positions the camera on the floor, looking straight up through the lampshade at the characters' chins. In the opening scenes of *Raw Deal*, when Claire Trevor visits Dennis O'Keefe in prison, the photographic drama derives from shifts of focal lengths (in other words, strong shifts of depth from one shot to the next, with the wide-angle lens creating a dynamic, exaggerated depth and the long lens creating a flat space suitable for close shots of faces) and subtle attention to the spectrum of light and dark: steely gray prison walls; diffused, purgatorial interiors; and glowing closeups of Trevor, who wears a fragile veil, her eyes sparkling like diamonds.

Alton didn't break the rules of Hollywood lenses and lighting, but his style marked him as distinctive. A more conventional but no less effective approach can be seen in Nicholas Musuraca's photography for Jacques Tourneur's *Out of the Past*, which exhibits relatively few of the techniques usually associated with Alton: no night-for-night scenes, no distorting lenses, no extreme deep-focus, no "choker" closeups, and very few radical angles. The film was produced at RKO, where nearly everything—including the Astaire/Rogers musicals, *Citizen Kane*, and a host of RKO noirs—had India-ink blacks and silvery whites. Musuraca and Tourneur had previously collaborated there on Val Lewton's production of *Cat People* and were particularly good at working within conventions to create romantic, sensuous, and sinister moods.

The most elemental problem Musuraca or any Hollywood photographer faced on a project like *Out of the Past* was the limited "color spectrum" of black and white, which could make objects blend into one another. He needed to master the photographic equivalent of a longstanding tradition in painting called "grisaille," or the technique of working in many shades of black, gray, and white. Costuming and set design determined his lighting strategies: Robert Mitchum's beige trench coat had to be visible against a gray wall, people and automobiles had to be "readable" in night-time scenes, and both the characters and the décor needed to be modeled with light to give them dimension. When Jane Greer makes her dramatic entrance into the film, walking toward an open archway of an Acapulco cantina, she wears a white dress and matching straw hat that make her almost invisible in the sun of the plaza outside; but when she steps into the cool shadows of the cantina, she seems to materialize out of brightness, becoming first a silhouette and then a fully visible, modeled figure against a shaded wall. In the opening sequences, when a gangster enters the bright, perfectly clear daylight of Lake Tahoe, Nevada, his black hat and black trench coat make him look (to borrow a line from Raymond Chandler) as conspicuous as a tarantula on a slice of angel food.

For darkened scenes, the film creates an air of mystery or tension by lighting characters with a hard light from the side, so that half or more of their faces are in darkness. Whenever the audience needs to read the expression on a partly obscured face, Musuraca uses a soft "fill" to lighten the shadow; and in scenes where the foreground and background have roughly the same illumination, he uses a "rim" or "liner," hidden behind the actors, outlining their hair with a glow. In the chief gangster's abode, he employs "Jimmy Valentine" light, throwing high shadows on walls and lending a Gothic quality to faces; he also positions lights so that the edges of picture frames or furnishings cast shadows. For an important sequence in which danger and eroticism are intertwined, he uses a combination of "Jimmy Valentine" lights and strategically placed

rim, liner, and background lights: private eye Mitchum sneaks
into femme fatale Greer's San Francisco apartment and stands in
a shadowy area as she enters from another room to answer the
telephone; a rim light outlines the edge of his darkened profile,
and beyond him in the distance, a table lamp casts Greer's shadow
high on the wall. A reverse angle shows him stepping out of the
shadow, lit menacingly from below. She starts to run, but he
grasps her arm and pushes her down to a chair; in another reverse
angle, she lands roughly, her mink coat falling off and lamplight
spilling over her bare shoulders. Her black dress contrasts with
the gray upholstery of the chair, and the beauty of her sudden
closeup feels like a counterpunch to his violence (Figure 9).

Musuraca's artful work on this film relied on a basic repertory of
lighting techniques common to a great many Hollywood
pictures of the 1940s. The situation, however, was about to change.
In the early 1950s, Eastman Kodak created single-strip color
film and a dye process that eliminated the need for expensive
Technicolor. The new color stock appeared just as movies were

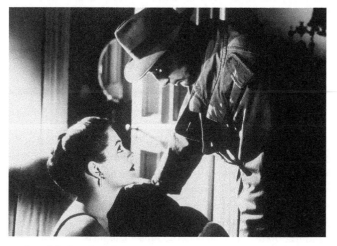

9. *Out of the Past* (1947).

trying to distinguish themselves from television, and by 1954 at least half the pictures in Hollywood were using some version of it, along with wide-screen aspect ratios. In the years between 1955 and 1970, the relative brightness of the process was ill suited to atmospheric movies about murder or psychological darkness.

The few color film noirs that had been made in the 1940s were more interesting, constituting what Borde and Chaumeton called experimental "limit works." Among these was the quasi-Freudian melodrama *Leave Her to Heaven* (1945), starring Gene Tierney as a murderously jealous heiress, for which photographer Leon Shamroy won an Oscar by combining "mysterious" Technicolor interiors—lamplit rooms, cast shadows, deep focus, low angles that brought ceilings into view—with spectacular landscapes shot in California and Arizona. Another color experiment was Hitchcock's *Rope* (1948), which was photographed almost completely on a single set representing a New York apartment, preserving "real duration" by unobtrusively linking together a series of long takes, many of them lasting ten minutes, the maximum allowed by available technology. A great deal has been written about this aspect of the film, but much less about *Rope*'s equally unusual approach to Technicolor.

Rope was Hitchcock's first color film, and was advertised by Warner Bros as the first picture in history to use color "for a suspenseful story of murder and detection." Hitchcock was intensely concerned about the color, even to the point of replacing the talented cinematographer Joseph Valentine, with whom he had worked on *Shadow of a Doubt* (1943), midway through the production. At one point, Valentine had photographed an artificially created sunset outside the panoramic windows of the apartment, and when Hitchcock saw the rushes he thought the sun was too bright orange, "like a lurid postcard." He fired Valentine and reshot those ten or twenty minutes, changing the look of the sunset and insisting on a subdued color throughout.

In his interview with François Truffaut, Hitchcock explained that his major discovery in working on the picture was that "things show up much more in color than in black and white." He believed there was no need for elaborate lighting schemes that outlined the actors or cast shadows on walls, because color made it easier to separate foreground from background. His aim was to maintain a discrete color palette in keeping with the upper-class, artistic-intellectual world in which the film is set; even the art hanging on the walls of the Manhattan apartment consists mainly of pen-and-ink drawings or gray-and-white paintings. But with each successive long take, as late afternoon transitioned into evening, Hitchcock's technicians subtly rearranged the lighting. In shot number five, the horizon outside the apartment windows is amber and shadows have overtaken parts of the room. A dinner party is in progress, and one of the guests, played by James Stewart, turns on a lamp atop a piano. A nervous Farley Granger snaps, "Would you mind turning that off?" In shot six, the apartment has become so dark that a maid needs to turn on lights as she extinguishes the dinner candles and cleans up after the party; outside, we see a thin rosy line on the horizon, and amid the lights of the skyscrapers a tiny neon blinks red. Finally, in the last shot, when night has completely fallen, Hitchcock gives the film its only moment of garish color. James Stewart opens a trunk at the center of the room, where two murderers have concealed a body, and a closeup shows his reaction. Through a small window at one side of the apartment, a large "S" on a neon sign flashes, shading Stewart's face with a sickly green and then a bloody red.

Few crime movies shot in color over the next decade attempted to follow Hitchcock's example. *Niagara*, photographed by Joe MacDonald, featured postcard views of Niagara Falls and provocative images of Marilyn Monroe in a red dress, but also contained atmospheric scenes involving the typical inky shadows of film noir; *Slightly Scarlet* (1956), photographed by John Alton in Technicolor and "Superscope," had a few scenes with "Jimmy Valentine" lighting; and Russell Metty used black-and-white

lighting schemes for two sumptuously colored, woman-in-danger thrillers: *Midnight Lace* (1960) and *Portrait in Black* (1960). Two European noirs—René Clément's *Purple Noon* (France, 1960) and Michael Powell's *Peeping Tom* (Britain, 1960)—had vibrantly expressive but relatively shadow-less color. Gradually, the techniques of what Alton called "mystery" light seemed to fall into disuse. Gerd Oswald's *A Kiss Before Dying* (1956)—a noir title if ever there was one—was photographed by Lucien Ballard in wide-screen color, sans shadowy effects. Don Seigel's remake of *The Killers* (1964), originally intended as a TV movie, was full of noir-like sadism and double dealing but was photographed in band-box colors, with a bloody conclusion that takes place on a sunlit, suburban front lawn.

Unquestionably, the best uses of color for crime pictures in the 1950s were in Hitchcock's *Rear Window* (1954) and *Vertigo* (1958), both of which were photographed by Robert Burks. Both flaunted the beauty of Paramount's Vista-Vision process, and both made the glamor of color indispensable to suspenseful and oneiric scenes. In 1960, however, Hitchcock shot *Psycho* in black and white, partly because he wanted to duplicate the style of his popular TV series and partly because he thought the shower scene would be too ghastly in color. In 1964, the Beatles went against the commercial grain by making their movie debut, *A Hard Day's Night*, in black and white. Billy Wilder worked in a wide-screen, black-and-white format for most of that period, even for his comic pictures. Until the middle of the decade, black and white was associated primarily with European art films of Bergman, Antonioni, Fellini, Resnais, etc. But in the last half of the 1960s, two "art" thrillers by European directors—Antonioni's *Blowup* (Britain, 1966) and John Boorman's *Point Blank* (1967)—used experimental color schemes, and not long afterward Hollywood learned that rich black shadow could be created in a color medium.

No photographer was more important to the latter development than Gordon Willis, who became known as "the prince of

darkness" because of low light levels he achieved in *Klute* (1971), the first two parts of *The Godfather* (1972 and 1974), and the paranoid thriller *The Parallax View* (1974). Willis's camera operator, Michael Chapman, was director of photography for *Taxi Driver*, and told interviewers that while working on the color for that film he and Martin Scorsese looked at "*film noir, Sweet Smell of Success*, things like that." He added, "if you are above a certain age, you tend to think that real movies are in black and white."

Other photographers began augmenting the old-style lighting effects with new forms of color expressionism; in *Body Heat* (1981), for example, Richard H. Klein used blue and red gels on lights to divide rooms or faces into "hot" and "cold" areas. Still others experimented with a color twilight, as in Jordan Cronenweter's photography for *Cutter's Way* (1981), which was shot almost entirely at "the magic hour" of late afternoon. Today, nearly all films are shot in color, and the exceptional versatility of digital cameras allows for the possibility of a range of atmospheric effects in natural light. But because cinematographers still admire the old film noirs, color pictures with criminal themes continue to aspire to the condition of black and white. A typical example is David Fincher's Netflix TV series *Mindhunters* (2017), in which the color palette is limited, the faces are in half shadow, and the irises of the actors' eyes sparkle with a special light.

Parody, pastiche, and postmodern noir

At the height of Hollywood's film noir in the 1940s, it became the subject of comic parody. In the Paramount comedy *My Favorite Brunette* (1947), for instance, Alan Ladd makes a cameo appearance as a tough gumshoe who has an office next to Bob Hope's (Ladd and Hope were among the studio's biggest stars). During the same period, there was a song entitled "The Postman Rings Twice, the Iceman Walks Right In," and a James Thurber short story called "Hell Only Breaks Loose Once." Almost

simultaneously, S. J. Perelman wrote a *New Yorker* parody of Raymond Chandler entitled "Farewell, My Lovely Appetizer."

The rise of Hollywood's "neo-noir" in the 1970s and 1980s led to another series of comic parodies or burlesques of 1940s noir, including *The Black Bird* (1975), *The Cheap Detective* (1978), *Dead Men Don't Wear Plaid* (1982), and a black-and-white episode of the TV series *Moonlighting* (1985) entitled "The Dream Sequence Always Rings Twice." But all this didn't mean that noir was being derided or criticized as a passé form. Parody has a Janus-like quality, allowing it to be both critical and affectionate; depending on its aims and context, it can be a savage deflation, a nostalgic tribute to a beloved object, or a sign of popularity and high approval. Chandler, for example, was delighted with what S. J. Perelman had written, and they became friends.

Consider the satiric but also celebratory effect of the "Girl Hunt" ballet" in Minnelli's *The Band Wagon*—a lavishly designed dream sequence starring Fred Astaire as private eye Rod Reily and Cyd Charisse as both a blonde ingenue and a brunette femme fatale. Astaire moves through surreal Technicolor settings and dances up fire-escapes to nowhere, repeatedly getting knocked out by bad guys. In a twist on the usual formula, the blonde turns out to be the villain he pumps full of lead, and he goes off at the end with the brunette. "She was bad," his narration tells us. "She was dangerous. I wouldn't trust her any further than I could throw her. She was my kind of woman."

Like many parodies, "The Girl Hunt" achieves its comic effects by exaggerating selected conventions from a narrow range of well-known prior texts (in this case, tough private eye pictures such as *Murder, My Sweet, The Big Sleep,* and *Out of the Past*) and putting them in a radically different context: we have tough offscreen narration, repeated beatings, a femme fatale, and so forth; but also Astaire instead of Bogart and Technicolor dance instead of black-and-white drama. Borde and Chaumeton

described it as a "poetic transformation" created by a "tortured aesthete," and as a sign that noir had become little more than a "memory." But film noir was still quite alive when *The Band Wagon* appeared (Aldrich's *Kiss Me Deadly* was made two years later), and Minnelli had been contemplating such a dance number since the late 1930s.

One could nevertheless argue that Minnelli was able to poke fun at noir because certain of its qualities had become so familiar (or clichéd) that they were nearing exhaustion. Even in 1947, *Out of the Past* had so many familiar noir conventions that it seemed on the verge of self-parody: a trench-coated, chain-smoking private eye; an innocent blonde ingenue; a dark-haired femme fatale; a flashback narrative with a first-person narrator who tells a story of passion, murder, and betrayal; a down-beat ending; and a romantic theme song played not only as background music but also by every jazz band and barroom pianist in sight. But the power of *Out of the Past* has something to do with its effective use of conventions, and "The Girl Hunt" was quite fond of the conventions it mocked and beautifully imbued with the stylish, utopian spirit of Hollywood musicals.

Pastiche, a related technique, resembles parody in that it involves selective borrowing, but it seldom has a comic or critical effect. The term has a long history, originating in the Italian "pasticcio" or "mixed dish," and was used in the 17th century to describe paintings that imitated and mixed together the styles of various prior artists. According to the *Oxford English Dictionary*, English uses of the term became common in the 19th century, referring to works of art of any kind that imitated (as opposed to forging) an earlier model. Richard Dyer, who has written the best book on pastiche in films, points out that two connotations have adhered to the term for much of its history: it can indicate an artistically valid practice of imitation, or, more often, a shallow copy, as in "mere pastiche." Cultural theorist Fredric Jameson uses it in the negative sense to describe postmodern art, which emerged in the

early 1960s with the mainstream recognition of camp, the pop-art movement, and the arrival of such books as Susan Sontag's *Against Interpretation* and Robert Venturi's *Learning from Las Vegas*. (The Las Vegas architecture Venturi praised has today become pure pastiche, featuring an Eiffel Tower, an Egyptian pyramid, and a Venetian lagoon.) Jameson argues that pastiche is blank parody, lacking the normative or critical standards associated with modernist art, and reflecting the cultural logic of late capitalism. Dyer has what strikes me as a more complex and persuasive argument, quarreling with "the assumption in the majority of uses that pastiche is intrinsically trivial or worse."

No matter what one might think of pastiche, both it and parody can be understood as playful forms of what Gerard Genette calls "hypertextuality," in which the style of one text (or film) deliberately evokes memories of another. Pastiche obviously hasn't been confined to postmodernism; we need only think of novels by Miguel de Cervantes, Henry Fielding, Laurence Sterne, Gustave Flaubert, and James Joyce, all of whom use mixtures of pastiche and parody to create complex relations to older texts. Just as clearly, however, pastiche became a dominant form of postmodern art in the 1970s and 1980s. During that period, especially where movies were concerned, it had a short memory, mainly imitating American popular art since the 1930s. Historical film noir was one of the chief memory banks it drew from, but even then, its memory was limited.

European directors of the 1960s and 1970s, some of whom helped create the idea of American film noir, were more interested in an allusive, "pasticcio" technique than in a straightforward attempt to resuscitate moods and conventions of older pictures. Godard's *Breathless* and Rainer Fassbinder's *The American Soldier* (Germany, 1970) have a mixture of styles and are centered on characters who awkwardly imitate Hollywood gangsters or private eyes. Truffaut's *Shoot the Piano Player* (France, 1960) creates comic effects by lurching from one kind of movie to another—crime

film, western, slapstick comedy, and domestic melodrama. At the beginning, a man running desperately down a dark street bumps into a lamp post and is aided by a passing friend, who walks along with him chatting about domestic problems; later, Charles Aznavour and Marie Dubois walk down another dark street clothed in trench coats and seem almost like characters going to a costume party. These scenes are neither parodies nor "blank" imitations; they're part of the film's consistent aim of disrupting genre coherence. Truffaut told interviewers that he wanted to achieve "the explosion of a genre (the detective film) by mixing genres," and that he tried to create "a respectful pastiche of the Hollywood B films from which I learned so much."

Richard Dyer makes the crucial point that in the 1970s, a cycle of Hollywood films he calls "neo-noir" (a term he limits to films that employ pastiche rather than "pasticcio," and a term I adopt here in the narrow sense he uses) operated by a more conservative principle; they were both generically and stylistically coherent, they followed the patterns of conventional Hollywood narrative, and they played a role in the "development and perhaps even recognition" of film noir as a category. A key example was Lawrence Kasdan's *Body Heat*, which borrows knowingly from *Double Indemnity* but never seems exactly like a classic noir; a color film with soft-core sex scenes, it has an ironic ending that allows the femme fatale to get away with murder (escaping to Latin America, naturally), and a music score featuring "a languorous melody on tenor saxophone over strings." Dyer describes the music as what has become "par excellence the sound of noir," even though, he notes, saxophone and strings were never the basis for scores in the 1940s and 1950s. What neo-noir imitates, he concludes, "is not straightforwardly noir but the memory of noir, a memory that may be inaccurate or selective."

All pastiche is selective, otherwise it would be forgery; but *Body Heat*, like several other films of its type, has a different memory than the French New Wave. It reminds us chiefly of Billy Wilder's

classic film, which was known to many, and evokes nostalgia for something that never quite was. The French, on the other hand, reminded their audience of B pictures and lesser-known films; they didn't imitate conventional narrative strategies, and their range of allusion was much broader. *Shoot the Piano Player*'s most specific borrowing from Hollywood noir—an overnight drive from Paris to a snow-bound countryside, viewed through the front window of a car—is inspired by a similar scene in Nicholas Ray's *On Dangerous Ground* (1952). At other points, it alludes to Jacques Tourneur's *Nightfall* (1956), which, like *Shoot the Piano Player*, was based on a book by noir novelist David Goodis. Its music is a mixture of classic piano, jazz, and French chansons; and its cultural references include Charles Chaplin, Errol Gardner, the Marx brothers, Max Ophuls, Alain Resnais, William Saroyan, and Art Tatum. Godard's *Breathless* (Figure 10) is even more encyclopedic: its central character identifies with Bogart, but it also contains pop culture references to noir directors Robert Aldrich, Samuel Fuller, Budd Boetticher, Jean-Pierre Melville, Otto Preminger, and Raoul Walsh; and high culture references to William Faulkner, Pablo Picasso, Rainer Maria Rilke, Louis Aragon, Guillaume Apollinaire, and William Shakespeare.

Among other examples of Hollywood neo-noir in Dyer's limited sense are the Coen brothers' *Miller's Crossing* (1990), which imitates style and story elements from Hammett's novels but never deals seriously with politics; and Peter Medak's *Romeo is Bleeding* (1993), in which venetian-blind shadows are seen everywhere and the femme fatale is a gun-toting, one-armed dominatrix. In this category I would also place a series of noir remakes, none as good as the originals and not all of them retro-styled: *Farewell, My Lovely* (1975), *The Big Sleep* (1978), *Against All Odds* (1984), *D.O.A.* (1988), and *Kiss of Death* (1995).

I would exclude from this list Quentin Tarantino's *Pulp Fiction* (1995), which imitates both the French New Wave and American noir. I agree with Tarantino, who has claimed he doesn't do

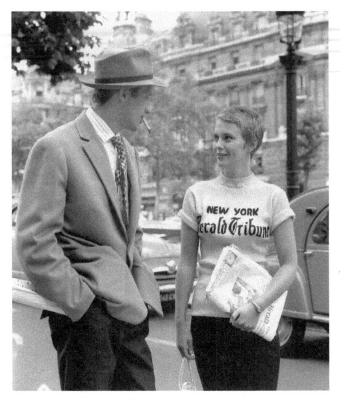

10. *Breathless* (France, 1960).

neo-noir. Like the French, he uses "pasticcio," sampling many kinds of film and engaging in a frenzy of allusion. In *Pulp Fiction* he evokes memories of *The Big Sleep*, *Gun Crazy*, *Kiss Me Deadly*, *The Killers*, *The Set-Up*, and *Chinatown* ("after you, kitty cat"); he takes ideas from *The Deer Hunter* (1978), *Deliverance* (1972), *Walking Tall* (1973), and his own *Reservoir Dogs* (1992); he pays tribute to European directors Godard, Fassbinder, and Melville, along with Americans Fuller, Ferrara, Peckinpah, Scorsese, and Sirk; and he references a personal pantheon of male-adolescent, "bubblegum" culture: Italian

exploitation movies (*Zombie*), cheap cartoons (*Clutch Cargo*), motorcycle pictures (*The Losers*), and kiddie heroes (Lash LaRue, Fonzie, Charlie's Angels). For all his talent and youthful vigor, however, his cultural frame of reference is relatively narrow, confined mainly to testosterone-driven action movies, hard-boiled literature, and pop-art material like *Modesty Blaise*. Except for his debts to the auteurists of the French New Wave, he remains almost entirely within the sphere of commercial entertainment and mainstream Hollywood.

Pastiche noir persisted into the 21st century. Brian De Palma's hyper-imitations of Hitchcock and other noir filmmakers continued with *Femme Fatale* (2003). Robert Rodriguez and Frank Miller's *Sin City* (2003), the most successful of several attempts at computer animated "noir-ness," looks rather like Mickey Spillane on steroids meeting a nasty version of a Chuck Jones cartoon—a black-and-white world filled with female eye candy and grotesque violence, streaked with bloody red. But throughout this period, there were also many good films we could call noir that didn't involve pastiche, among them *The French Connection* (1971), *The Killing of a Chinese Bookie* (1976), *Straight Time* (1978), *Croupier* (1999), *The Cooler* (2003), and *Collateral* (2004).

Some of the most interesting cases were films that drew on classic models but can be labeled parody or pastiche in only a qualified sense. Robert Altman's *The Long Goodbye* (1973), which is based on a late, relatively disappointing Raymond Chandler novel, subjects the world of Philip Marlowe to a certain amount of derisive parody and jokes. Elliott Gould is intentionally miscast as Marlowe, and the setting is updated to contemporary, dope-crazed Los Angeles, where Chandler's romantic private eye becomes an anachronism. Altman's Marlowe is a chain-smoking slob, a sentimental nerd, and (like Chandler) a cat lover. At one point we hear a cop say, "Marlowe with an 'e.' Sounds like a fag name." Historical dissonance is especially evident in the film's style, which

involves Panavision zoom lenses, improvised dialogue, unorthodox sound recording and mixing, and diffused color photography by Vilmos Zsigmond, who "flashed" the film negative, exposing it to light in order to degrade contrasts. Instead of classic noir's witty dialogue and wry offscreen narration, we have inarticulate characters and a Marlowe who constantly mumbles to himself; and in place of carefully framed compositions, we're given a roaming series of panning and zooming shots that flatten perspective. John Williams's orchestral background music is pure pastiche, echoed within the action by door chimes, a sitar, and a mariachi band. The conclusion of the film, which imitates the closing shot of *The Third Man*, is accompanied by the music of "Hooray for Hollywood." This strikes me as a mean-spirited reversal of Chandler's ending, suggesting contempt for both him and the movies of his era.

In other respects, however, *The Long Goodbye* is faithful to its source and engaging as mystery story. The initial version of the script was written by Leigh Brackett, a Hollywood veteran who had worked with Hawks on *The Big Sleep* and *Rio Bravo* (1959), and who delivered a relatively straightforward adaptation. Altman wanted to create an anti-Bogart movie. "I think Marlowe's dead," he told *Film Comment*. "I think *that* was 'the long goodbye.' I think it's a goodbye to that genre—a genre that I don't think is going to be acceptable anymore." But the film works best at Brackett's traditional level. When Altman tries to send up the novel with alienation effects and jokes about classic Hollywood, he accomplishes less than Chandler, who was already a critic of the movies. (Chandler was also more critical than Altman of policing in Los Angeles; the film merely makes jokes about the corruption of small-town Mexican cops.) Certain of Altman's more free-wheeling inventions, such as a vicious Coke-bottle attack on a woman and a running gag about stoned, bare-breasted girls who live across from Marlowe, exploit the liberalization of censorship by adding doses of misogyny and violence. Perhaps unsurprisingly, audiences weren't sure what to make of the film. Was it a Chandleresque

critique of LA's gangsters and hippies, or a pot-induced critique of Chandler? When it did poor opening business, United Artists withdrew it from circulation and designed a new set of trailers and posters to emphasize its parodic aspects.

A completely opposite use of the hard-boiled tradition is *Chinatown* (1974; (Figure 11)), which opens with Paramount Pictures' black-and-white logo of the 1930s and closes with the 1970s logo. The contrast between it and the Altman film is systematic: *The Long Goodbye* dispenses with an art director, but *Chinatown* relies heavily on Richard Sylbert's meticulous recreation of 1930s Los Angeles; *The Long Goodbye* is jokey and digressive in the manner of the French New Wave, but *Chinatown* is an engrossing, classically constructed thriller; *The Long Goodbye* inhibits identification with the protagonist, but *Chinatown* encourages it; *The Long Goodbye* treats old Hollywood derisively, but *Chinatown* returns wholeheartedly to the past, acknowledging its indebtedness to classic noir by casting John Huston in an important role.

But *Chinatown* can be called a pastiche or a retro-styled neo-noir only to a limited degree (*Devil in a Blue Dress*, which was influenced by it, is even less a pastiche). Photographed in Panavision by John Alonzo, it uses a highly mobile camera that enables the operator to walk with characters through doorways and into tight spaces. The new technology is selectively adapted to the feel of classic noir: in this case, the framing of most shots is precise and restrictive, and the color scheme, especially for some interiors, is muted and monochromatic. Screenwriter Robert Towne and director Roman Polanski were obviously devoted to old movies. "I love the clichés," Polanski told *Newsweek* when the film was released. Towne borrowed from both Hammett and Chandler, but Polanski went back to earlier models, imbuing *Chinatown* with touches of Gothic horror (one of his contributions was the shocking, downbeat ending). The particular qualities of the film arise from a productive tension between Towne's socially acute,

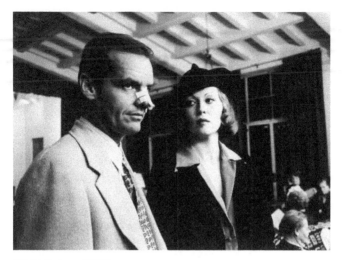

11. *Chinatown* (1974).

melancholy story and Polanski's perverse, absurdist sensibility—two attitudes that can be sensed in Jerry Goldsmith's theme music: a low, plaintive trumpet solo counterpointed with eerie strings (once again a "sound of noir" that never was).

In the last analysis, *Chinatown* is more like a period film than a pastiche; its historical details are scrupulously accurate (a character even smokes Lucky Strike Greens), and the liberties it takes with Los Angeles locations are in the service of an important goal. A serious critique of the American past, it emphasizes left-wing and Freudian themes that were only latent in classic noir, and in the process reverses a few noir clichés. Its protagonist, private eye J. J. Gittes (Jack Nicholson), is less heroic or effective than Sam Spade. A hothead and a bit of a vulgarian, he's dandified in an overdressed way and fastidious about his venetian blinds, liquor cabinet, and china coffee service. He horselaughs at dirty jokes, which he thinks his secretary shouldn't hear, and can't talk with a rich lady client without accidentally falling into profanity.

During the film, however, Gittes emerges as a more believable version of the fantasy Bogart once embodied—a man whose rough exterior conceals compassion and a sense of justice. We learn that he was once a policeman in Chinatown, where his job was "puttin' Chinamen in jail for spittin' in the laundry." Something happened there that haunts him; the film never says what, but it involved a woman he tried to help. During his present investigation, history repeats itself with a vengeance. His involvement with the wealthy, enigmatic Evelyn Mulwray (Faye Dunaway) is vaguely reminiscent of *Vertigo* (1958): the woman in the present is an echo of the woman in the past, and after the detective has peeped into other lives and found the secret of a murder, he's crushed under the guilt he tried to overcome. The ultimate irony is that when he returns to Chinatown, Gittes is handcuffed to the shooting arm of a policeman who kills someone Gittes wants to protect.

Chinatown also resembles Hitchcock because Polanski greatly heightened the subjectivity of Towne's screenplay, shooting nearly everything from Jake's point of view and repeatedly showing him peering through camera lenses or windows. Despite this emphasis on voyeurism, however, the treatment of Evelyn Mulwray is unusual; given the conventions of film noir, we expect her to be evil, but the creepy patriarchal embrace she experiences is linked to an epic irrationality and greed, a disease that embraces the entire city and surrounding valley. Towne based his script on an actual scandal that hit Los Angeles in the early decades of the 20th century, when rich men bought cheap farmland and had it incorporated into the city, gaining control over the water supply and cementing capitalist power relations for long afterward. (Robert Zemeckis's *Who Framed Roger Rabbit?* (1998), a mixture of parody and pastiche that owes something to *Chinatown*, is also based on a true history of chicanery in Los Angeles, involving the city's transit system.) Unlike many post-1950s noirs, this vision of 1930s Los Angeles isn't simply a nostalgia trip; on the contrary, it makes the 1930s a metaphor for American society in 1974, at the time of Vietnam and the Watergate scandal.

At another end of the spectrum, and more typical of postmodernism, are David Lynch's *Lost Highway* (1997) and *Mulholland Drive* (US–France 2001), which, by abandoning conservative Hollywood narrative conventions, transcend nostalgic imitation. Perhaps because the screenplay of *Lost Highway* was written by Barry Gifford—a noir novelist and author of a book about noir entitled *The Devil Thumbs a Ride*—it brims with allusions and archetypal characters: a nocturnal auto ride out of *Detour* and *Psycho*; an exploding house on stilts out of *Kiss Me Deadly*; an alienated jazz musician who might be a killer; a brooding rebel who lusts after a gun moll; a sadistic gangster who enjoys pornographic movies; a mutilated woman's body reminiscent of the Black Dahlia; and not one but two femme fatales—a redhead like Gilda and a blonde like Phyllis Dietrichson. Throughout all this, however, Lynch suspends narrative logic, creating a dream. The characters abruptly change identities or become doubles, and the plot twists back on itself, generating a powerful atmosphere of desire, terror, and dread. The result is something like the ideal "noir-ness" imagined by French Surrealists in the decade after World War II—noir with the gloves off, foregrounding oneiric, sado-masochistic, blackly humorous, and disorienting effects.

Mulholland Drive (Figure 12) is equally disorienting, but I think superior. "Pasticcio" in style, it takes a female point of view, mingles dread with heartbroken emotional longing, and invites us to care deeply about its chief character, a wide-eyed blonde named Betty (Naomi Watts), newly arrived in Hollywood in search of a career as an actor. Betty meets a mysterious, raven-haired beauty (Laura Elena Harding) who, after experiencing an auto accident on Sunset Boulevard, suffers from amnesia. Seeing a framed poster of Rita Hayworth in *Gilda*, the dark-haired woman decides to call herself "Rita" ("There never was a woman like Gilda," the poster says). In the spunky style of a Nancy Drew detective, Betty tries to help Rita find her true identity. She also has a stunningly successful audition at Paramount, where she

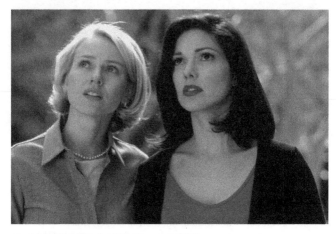

12. *Mulholland Drive* (US–France, 2001).

gives sexy subtext to an otherwise clichéd scene. Not long afterward, she and Rita become passionate lovers. These events are mingled with sinister or blackly comic episodes involving other characters and events, some apparently unrelated to the Betty/Rita story.

Further complicating things, *Mulholland Drive*, like *Lost Highway*, has a two-part, "hinged" narrative. About three-quarters of the way into the film, the camera enters an open box and emerges in a different world. Betty is now Diane Selwyn, a struggling actor of bit roles, and Rita is Camilla Rhodes, a movie star with whom Diane is having an affair. (We learn that Diane once lost a role to Camilla, who has "helped" her ever since.) When Camilla breaks off the affair, Diane suffers the humiliation of watching Camilla marry her director and acquire a new lover.

Mulholland Drive began as the pilot for a TV series similar to Lynch's *Twin Peaks*. But because the network wanted changes, Lynch found a French producer, added material for a second part, and created a feature film, leaving his viewers to puzzle out the

intricate relationship between motifs and characters in parts one and two. One could argue that part one is a dream story, but the closing scenes at the "Club Silencio" can hardly be called an assertion of the real; they have more in common with what Slavoj Žižek has called the "ridiculous sublime" (or what could also be called the "camp sublime"). Here as throughout, music is important, but not the sort we associate with noir. Lynch composed incidental music of his own, aided by Angelo Badalamenti, whose theme is heard at several junctures, sometimes triumphant and joyful, sometimes slow and funereal, like a mysterious *Liebestod*. Equally memorable are pop tunes from the 1950s and 1960s: the Connie Stevens recording of "Sixteen Reasons," the Linda Scott recording of "I've Told Every Little Star," and above all Roy Orbison's "Crying," performed in Spanish by Rebekah del Rio in the final sequence. Like the previous tunes, this last one is lip-synched. *"No hay banda"* the master of ceremonies says. *"Il n'y a pas d'orchestre,"* "It's all on tape!" But Lynch's emphasis on fakery doesn't diminish the wrenching emotional effect—a rare feeling in the ironic universe of postmodern art.

Chapter 6
The afterlife of noir

In 1993, Emmy Award-winning filmmaker Ara Checkmayan found a Maltese Falcon statuette in a Pennsylvania flea market. Believing it to be one of two identical props that were used in the 1941 movie, he purchased the black bird for eight dollars and offered it for auction at Christie's, who estimated its value at $50,000. Before the auction could take place, a Los Angeles collector pointed out that similar statuettes could be bought for forty-five dollars from a bookstore in Long Beach. (That year, my wife bought one for me at a Westwood bookstore.) But Checkmayan wasn't deterred; his rara avis was authenticated by a dealer in film memorabilia and sold at auction for $92,000. Meanwhile, Dr Gary Milan, a Los Angeles dentist, purchased another copy from the Warner Bros property department for $70,000. Still another copy, originally belonging to Jack Warner and presumably bearing the knife marks from the scene in which Sydney Greenstreet discovers it is made of lead, was sold to jeweler Ronald Winston for $398,000.

These and other details about the afterlife of the Maltese Falcon statuette have been discussed in an essay by film theorist and historian Vivian Sobchack, the irony of which is of course that Dashiell Hammett's "original" was fake, and that his novel can be read as a parable about art, surplus value, and the power of myth. (Notice that some of the villains in 1940s film noir were art

dealers.) A similar myth now surrounds the golden age of the Hollywood movie studios. *Pace* Walter Benjamin, mechanical reproduction hasn't destroyed the "aura" of art. On the contrary, in today's media environment a kitschy prop emblematic of film noir has become both the stuff that dreams are made of and a highly valuable objet d'art that can be displayed in museums.

Noir can also have other "platforms." In 1997, Carly Simon recorded an album entitled "Film Noir" (except for the theme from *Laura*, its connection with the films is tenuous). Such things happen because the modern arts-and-leisure economy comprises a mediascape in which stories, styles, and formulas move around from one kind of venue to another. The situation isn't new. Vera Casperay's *Laura* was a *Collier's* magazine serial in 1942, a novel in 1943, a movie in 1944, and a Broadway play in 1946. Hammett's *The Maltese Falcon* began as a *Black Mask* serial but became a novel, three movies, and inspiration for a couple of radio and TV series featuring Sam Spade.

Orson Welles's Campbell Soup radio program adapted Hammett's *The Glass Key* in 1939, well before Paramount made its Alan Ladd version of the novel. Beginning a few years later, one of the most popular radio shows in the US was CBS's *Suspense*, which featured a galaxy of Hollywood stars, spawned a magazine, and was as noir-like as anything in movies: James Stewart played a doctor who tries to escape his marriage by faking his death, Mickey Rooney played a murderous jazz musician who hears drums in his head, and Ida Lupino played a career woman whose ex-con husband threatens to shoot her. The show premiered in 1942 with an adaptation of *The Lodger*, directed by Alfred Hitchcock, and eventuated in over 900 episodes introduced by a character named "The Man in Black," who was the basis for suave radio storyteller Claude Rains in Michael Curtiz's film noir *The Unsuspected* (1947). Its most successful broadcast was Lucille Fletcher's award-winning 1943 drama "Sorry, Wrong Number," starring Agnes Moorhead, which in 1948 became a film noir starring Barbara Stanwyck.

In the early 1950s, EC Comics published two noir titles, *Crime Suspensestories* and *Shock Suspensestories*, filled with restless suburban marriages, neurotic killers, and corrupt police who gave the third degree to innocent victims. Drawn in angular, chiaroscuro style, the stories often involved murders of voluptuous women, but they also treated controversial subjects such as race prejudice and drug addiction. When guardians of morality shut them down, the EC organization experimented with a more expensive, adult line of "picto-fictions" that included *Shock Illustrated: Adult Psychoanalytical Tales*.

The *Suspense* radio show had died off, but was soon replaced by *Alfred Hitchcock Presents*, a top-rated CBS-TV show of 1955–62 that specialized in writers of noir fiction (many of whom also appeared in *Alfred Hitchcock Mystery Magazine*) and led to Hitchcock's greatest box-office success, *Psycho*. On TV in the late 1950s, private eyes were ubiquitous, though not always particularly noir-like. David Janssen was *Richard Diamond, Private Detective* (1957–60), Philip Carey was *Philip Marlowe* (1959–60), Darren McGavin was *Mickey Spillane's Mike Hammer* (1957–60), and Craig Stevens was *Peter Gunn* (1958–61). The best-known radio and TV police procedural from 1949 until the early 1970s was Jack Webb's *Dragnet*, which was inspired by the film noir *He Walked by Night* (1949) and became a movie in 1954.

It would require a lengthy chapter merely to list all the burnt-out police officers and philosophical private eyes in film and television entertainment since the 1960s. Noir continues to be an unusually flexible, pervasive, and durable mood or narrative tendency, embracing different media and different national cultures. Its moods and imagery have been appropriated across the range of filmmaking practice, from Christopher Nolan's *Batman* franchise (inspired by Frank Miller's noir-like DC comics) to avant-garde or independent features such as Sally Potter's *Thriller* (1979), Manuel DeLanda's *Raw Nerves: A Lacanian Thriller* (1980), Hal Hartley's *Simple Men* (1992), and Atom Egoyan's *Exotica* (1994).

Thanks to the well-informed, engaging Eddie Muller, who has written books on noir and was a founder of the preservationist Film Noir Foundation, there is currently a "Noir Alley" series on Turner Classic Movies, together with a Turner website where viewers can purchase noir accessories such as martini glasses (seldom seen in classic noir) and vintage noir movie posters. Perhaps noir will someday experience the kind of cultural repurposing and transformation described by Thomas Pynchon in his 1990 novel *Vineland*, which imagines a newly constructed "Noir Center" shopping mall in lower Hollywood with a mineral-water boutique called "Bubble Indemnity" and a perfume store called "The Mall Tease Flacon."

The question arises, however, whether film noir—indeed any film in the sense of a ninety-minute or two-hour narrative seen on a big screen by an audience in a movie theater—will survive in decades to come. Movies are now viewed in near isolation on a variety of screens, from home theaters to mobile devices. Streaming networks are replacing cable TV, and audiences for noir-like narratives have become accustomed to bingeing on series like *Breaking Bad*, which have the expansiveness of a three-decker Victorian novel. The internet is filled with film noir blogs or sites, which are only a small part of a brave new world of visual distractions that threaten to overwhelm all but the special-event theatrical attractions. Feature-length noir hasn't disappeared, but in the new digital media environment Steven Soderbergh has experimented with *Unsane* (2018), a claustrophobic thriller shot with a device he believes will become the "future" of filmmaking: the iPhone camera.

The popular memory of noir persists, although as I've indicated it tends to be partial, centered on a few influential Hollywood classics. In this short volume I've tried to dispel some of its inaccurate myths or "dreams," including the following: Film noir can't be dated 1941–58 because there were earlier and later noir pictures. Not all the films called noir are dark and shadowy, and not all take place

in the city; some use broad daylight, and some are westerns. Although noir is associated with Hollywood, a great many films of the type have come from other nations. The first to be called noir were made in France, not Hollywood or Germany, and unless we think the Germans invented shadows and stairways, relatively few have anything in common with German expressionism. Fritz Lang denied that his work was ever expressionist, and historian Thomas Elsaesser has pointed out that most of the Weimar directors who came to America in the 1930s and 1940s weren't associated with thrillers or street films; the most famous German film by Wilder, Siodmak, and Ulmer, he reminds us, was *Menschen am Sonntag* (Germany, 1930), from which, Elsaesser amusingly suggests, we could deduce a German influence on Italian neorealism. And while the initial cycle of Hollywood noir created a few memorable femme fatales—or, as in *Shadow of a Doubt* and *The Third Man*, homme fatales—roughly two-thirds of the 1940s and 1950s films called noir have nothing to do with fatal women. Even those that involve such characters can't be explained, as they sometimes have been, as a reflection of male resentment or anxiety toward the women who occupied the American work force during World War II. The femme fatale has an older history; most of the Hollywood films about her were adapted from popular fiction of the 1920s and 1930s, and similar films were in vogue during the 1970s and 1980s.

The chief way of defining film noir or shaping the category has always been ostensively, by means of a list. Most of the Hollywood film noirs listed by French critics in 1946 are still associated with noir, but as time has passed the lists have grown, encircling the globe and making the category increasingly heterogeneous. In the last analysis, film noir is impossible to organize in a definitive way. I make this statement not as a scandalous revelation or a debunking, but as an observation about how all cultural categories or genres are shaped. In *The Order of Things*, philosopher/theorist Michel Foucault has pointed out the inherent problem of attempting to "tame the wild profusion of things." The classical field of natural history, he argues, is "nothing more than the nomination of the

visible... relative to the criteria one adopts," and like most categories it's "subject to certain imprecisions as soon as deciding the question of its frontiers arises." Most attempts at classification, Foucault maintains, are "utopian" in their desire to maintain an order of similarities and differences and are threatened by a "heterotopia" of data.

This explains why lists of film noirs often raise puzzling questions about the choice of individual pictures and their arrangement in subcategories such as "neo-noir," "horror-noir," "sci-fi noir," or "western noir." One encounters the problem as early as Borde and Chaumeton's ground-breaking book. The appendix to the first edition of the *Panorama* lists eighty "major titles—post 1940," grouped into six subcategories: "Films noir," "Criminal psychology," "Crime films in period costume," "Gangsters," "Police documentaries," and "Social tendencies." But why make a separate category for "Films noir?" Do the films outside that group have only secondary importance? Why is *Phantom Lady* listed under "Films noir" but *Double Indemnity* under "Criminal psychology?" Why are *Crossfire*, *The Enforcer*, and *The Big Heat* each listed twice under different rubrics, when many other of the eighty titles could be given the same treatment? And why do Borde and Chaumeton list *Our Town* (1940) at all?

Lest we think the authors of the *Panorama* were nodding, consider the current list of classic American film noirs on Wikipedia, which begins in 1940 with *The Letter* and *Rebecca* and ends in 1959 with a host of films. Among the titles that might give viewers pause are Robert Rossen's *All the King's Men* (1949), which is an adaptation of Robert Penn Warren's novel about a Huey-Long style politician, and King Vidor's *Beyond the Forest* (1949), which is a modernized American version of Madame Bovary, famous in film history because it gave Bette Davis an occasion to say, "What a dump." The Wikipedia list of "neo-noirs" begins in 1960 (apparently the website believes that a new period began immediately after 1959), includes foreign films, and has several titles that might provoke a

skeptical response: Luis Buñuel's *Viridiana* (1961), François Truffaut's *The Soft Skin* (1964), Costa-Gavras's *Z* (1969), and Clint Eastwood's *High Plains Drifter* (1973).

This doesn't mean that the category is valueless, or that film noir doesn't exist. There may be no transcendent reason why we should have a noir category at all, but if we abandoned the term we would need another, equally problematic way to organize what we see. When we list any movie under the noir rubric, we invoke a network of ideas, moods, or themes as an organizing principle in place of other rubrics such as authors, movie studios, periods, genres, or national cinema (which we can also use). We should be grateful to preservationists, archivists, programmers, television networks such as Turner Classic Movies, digital distributors such as Criterion, and a variety of streaming sources for making so many films called noir available, sometimes in their original form and sometimes in digitally "restored" versions of amazing clarity. They began life as features in theaters, later appeared on the Late Show, were shown in 16 mm by collectors and in schools, were issued in VHS and DVD, and are now more widely available to viewers than ever before. They represent an important part of cinema's large, complex heritage, and are likely to have a long afterlife in one form or another.

The themes of the old noir thrillers—one-way streets and dead ends, mad love and bad love, double crosses and conspiracies, discontent in the nuclear family and violence around the corner—are as topical as ever, and the black-and-white films of the 1940s still contribute to a recurring pattern of modernity and postmodernity. Depending on how we use the term noir, we can make it stand for a dead period, a nostalgia for something that never quite existed, or an ongoing form. In any case, the last film noir will be no easier to list than the first.

References and further reading

Preface and Chapter 1: The idea of film noir

Among the many books on film noir are Ian Cameron, ed., *The Book of Film Noir* (New York: Continuum, 1993); Joan Copjec, ed., *Shades of Noir* (London: Verso: 1993); James Naremore, *More Than Night: Film Noir in its Contexts* (Berkeley: University of California Press, rev. edn, 2008); Justus Nieland and Jennifer Fay, *Film Noir* (New York: Routledge, 2010); Alain Silver and James Ursini, eds, *Film Noir Compendium: Key Selections from the Film Noir Reader Series* (New York: Applause Theatre and Cinema Books, 2016).

There are numerous sources that give lists of film noirs, among them Jim Hillier and Alastair Phillips, *100 Film Noirs* (London: BFI and Palgrave Macmillan, 2009), Spencer Selby, *The Worldwide Film Noir Tradition* (Ames, IA: SINK Press, 2013), and Alain Silver, Elizabeth M. Ward, James Ursini, and Robert Porfirio, eds, *The Film Noir Encyclopedia* (Woodstock: Overlook, 2010). On the internet, see especially the section on noir at DVDbeaver.com.

On French film noir, see Charles O'Brian, "Film Noir in France: Before the Liberation," *Iris* 21 (spring 1996), 7–20; and Ginette Vincendeau, "France 1945–1965: The Policier as International Text," *Screen* 33, no. 1 (spring 1992), 50–80.

Nino Frank, "Un nouveau genre 'policier': l'aventure criminelle," *L'Écran français* 61 (August 28, 1946), 15; and Jean-Pierre Chartier, "Les Americains aussi font des films 'noirs,'" *Revue du cinéma* 2 (1946), 68. Both are quoted in my translation. Full English translations are available in Alain Silver and James Ursini, *Film Noir Reader* (New York: Limelight, 1996).

Jean-Paul Sartre, *What is Literature?* Trans. Bernard Frechtman (New York: Washington Square Press, 1996), 156.

André Bazin, *What is Cinema?* Trans. Hugh Gray (Berkeley: University of California Press, 2 vols, 1967, 1971). See also the difficult to obtain, but more helpfully edited and better translated version by Timothy Bernard (Montreal: Caboose, 2009).

André Gide quoted in Diane Johnson, *Dashiell Hammett: A Life* (New York: Random House, 1983), 322 n. 7.

Bazin's remarks on Bogart quoted from Jim Hillier, ed., *Cahiers du Cinema: The 1950s* (Cambridge, MA: Harvard University Press, 1985), 99.

Louis Aragon quoted from Paul Hammond, ed., *The Shadow and its Shadow: Surrealist Writings on the Cinema* (London: BFI, 1978), 29.

Raymond Borde and Étienne Chaumeton, *A Panorama of American Film Noir*, trans. Paul Hammond (San Francisco: City Lights Books, 2002). The first French edition was published in Paris by Éditions de Minuit, 1955. Quotations are my translation, and page numbers refer to that edition.

Marcel Duhamel, introduction to Borde and Chaumeton, vii.

Borde and Chaumeton, 3.

Borde and Chaumeton, 10, 125.

Borde and Chaumeton, 12.

Mark Vernet, "*Film Noir* on the Edge of Doom," in Copjec, *Shades of Noir*, 24.

Borde and Chaumeton, 118, 277.

Raymond Durgnat, "Paint it Black: The Family Tree of Film Noir," is reprinted in Silver and Ursini, *The Film Noir Reader*, 37–51; and Paul Schrader, "Notes on Film Noir" is reprinted in the same volume, 53–63.

Dennis Hopper is quoted from Leighton Grist, "Moving Targets and Black Widows: Film Noir in Modern Hollywood," in Cameron, *The Book of Film Noir*, 267.

Robin Buss, *French Film Noir* (London: Marion Boyars, 1994).

Audun Englestad, *Losing Streak Stories: Mapping Norwegian Film Noir* (Oslo: University of Oslo Faculty of Humanities, 2006).

Chapter 2: The modernist crime novel and Hollywood noir

Eric Rohmer, "Rediscovering America," in Hillier, *Cahiers du Cinema: The 1950s*, 91.

David Lodge, "The Language of Modernist Fiction," in *Modernism: A Guide to European Literature, 1890–1930*, ed. Malcom Bradbury and James McFarlane (Harmondsworth: Penguin, 1991), 481–96.

Paul Grimstad, "Edgar Allan Poe: Emergence of the Literary Detective," in *A History of American Crime Fiction*, ed. Chris Raczowki (Cambridge: Cambridge University Press, 2018), 83–94.

Joseph Conrad quoted in Tony Hiller, *The Crime Novel: A Deviant Genre* (Austin: University of Texas Press, 1990), 98.

W. H. Auden, "The Guilty Vicarage," in *The Dyer's Hand and Other Essays* (New York: Vintage, 1968), 146–58.

Sam Rohdie, *Film: Modernism* (Manchester: Manchester University Press, 2015).

George Orwell, "Raffles and Miss Blandish," in *A Collection of Essays by George Orwell* (New York: Doubleday Anchor, 1954), 139–54.

Diane Johnson, *Dashiell Hammett: A Life* (New York: Random House, 1983).

Lee Server, *Danger is My Business: An Illustrated History of the Fabulous Pulp Magazines* (San Francisco: Chronicle Books, 1993).

Geoffrey Nowell-Smith and Joseph Sullivan, "Servants of Two Masters: Kurosawa's *Yojimbo* and Leone's *Fistful of Dollars*," *Journal of Romance Studies*, 4, no. 1 (spring 2004).

Geoffrey O'Brien, *Hard-Boiled America* (New York: Van Nostrand Reinhold, 1981).

Nunnally Johnson quoted in Diane Johnson, *Dashiell Hammett*, 124.

Norman Sherry, *The Life of Graham Greene*, 2 vols (New York: Viking, 1989, 1994).

Graham Greene, *The Pleasure Dome: The Collected Film Criticism 1935–40*, ed. John Russell Taylor (Oxford: Oxford University Press, 1980), 145, 230, 184.

Greene quoted in Norman Sherry, *The Life of Graham Greene*, Vol. I, 597.

T. S. Eliot, *Selected Prose* (Harmondsworth: Penguin, 1953), 181.

Roy Hoopes, *Cain: The Biography of James M. Cain* (New York: Holt, Reinhart and Winston, 1982).

Maurice Zolotow, *Billy Wilder in Hollywood* (New York: Limelight Editions, 1987).

Billy Wilder quoted in Cameron Crowe, *Conversations with Wilder* (New York: Alfred A. Knopf, 1999), 69.

Frank McShane, *The Life of Raymond Chandler* (New York: E. P. Dutton, 1976).

Chandler quoted in McShane, 84, 76, 77.

William Luhr, *Raymond Chandler in Hollywood* (Tallahassee: The Florida State University Press, 1991).

For the screenplay of *Double Indemnity* with the original ending, see Jeffrey Meyes, ed., *Double Indemnity: The Complete Screenplay* (Berkeley: University of California Press, 2000). My comments on the original ending derive from my research at the Margaret Herrick Library of the Motion Picture Academy in Los Angeles.

Francis M. Nevis, Jr, *Cornell Woolrich: First You Dream, Then You Die* (New York: Mysterious Press, 1988).

Chapter 3: Censorship and politics in Hollywood noir

On the Production Code Administration: Thomas Doherty, *Pre-Code Hollywood: Sex, Immorality, and Insurrection in American Cinema, 1930–1934* (New York: Columbia University Press, 1999); and Leonard Leff and Jerrold L. Simmons, *The Dame in the Kimono: Hollywood Censorship from the 1930s to the 1960s* (New York: Anchor Books, 1990).

Borde and Chaumeton, 19.

Siegfried Kracauer, "Hollywood's Terror Films: Do They Reflect a State of Mind?" *Commentary* (August 1946), 132–6.

John Houseman quoted in Richard Maltby, "The Politics of the Maladjusted Text," in Cameron, *The Book of Film Noir*, 41.

On the Popular Front: Michael Denning, *The Cultural Front* (London: Verso, 1997).

Nancy Lynn Schwartz, *The Hollywood Writers' Wars* (New York: Alfred A. Knopf, 1982).

Karen Morley quoted in Schwartz, 253.

Raymond Chandler quoted in McShane, 117.

Larry Ceplair and Stephen Englund, *The Inquisition in Hollywood: Politics in the Film Community, 1930–1960* (Garden City, NY: Garden City Press, 1980).

Richard Lingeman, *The Noir Forties: The American People from Victory to Cold War* (New York: Nation Books, 2012).

Thom Andersen, "Red Hollywood," in *Literature and the Visual Arts in Contemporary Society*, ed. Suzanne Ferguson and Barbara Groseclose (Columbus: Ohio State University Press, 1985).

E. Ann Kaplan, ed., *Women in Film Noir* (London: BFI, 1998).

R. Barton Palmer, *Hollywood's Dark Cinema: The American Film Noir* (New York: Twayne, 1994).

Richard Dyer, "Postscript: Queers and Women in Film Noir," in Kaplan, ed., *Women in Film Noir*, 123–9.

Homay King, *Lost in Translation: Orientalism, Projection, and the Enigmatic Signifier* (Durham, NC: Duke University Press, 2010).

Robert E. Kapsis, ed., *Charles Burnett Interviews* (Jackson: University of Mississippi Press, 2011).

Paul Arthur, "Los Angeles as Scene of the Crime," *Film Comment* (July–August 1996): 20–6.

Chapter 4: Money, critics, and the art of noir

Andrew Sarris, "The Beatitudes of B Pictures," in Todd McCarthy and Charles Flynn, eds, *Kings of the Bs* (New York: E. P. Dutton, 1975), 48–53.

Lea Jacobs, "The B Film and the Problem of Cultural Distinction," *Screen*, 33, no. 1 (spring 1992), 1–13.

Manny Farber, *Negative Space* (New York: Praeger, 1971).

Paul Kerr, "Out of What Past? Notes on the B Film Noir," in Paul Kerr, ed., *The Hollywood Film Industry* (London: Routledge and Kegan Paul, 1986), 220–44.

Noah Isenberg, *Edgar G. Ulmer: A Filmmaker at the Margins* (Berkeley: University of California Press, 2014); see also Noah Isenberg, *Detour* (London: BFI, 2008).

David Bordwell, "Thrill Me," <http://www.davidbordwell.net/blog/2017/06/03/thrill-me/>.

Chapter 5: Styles of film noir

Edward Dimendberg, *Film Noir and the Spaces of Modernity* (Cambridge, MA: Harvard University Press, 2004).

David Bordwell, *Reinventing Hollywood: How 1940s Filmmakers Changed Movie Storytelling* (Chicago: University of Chicago Press: 2017).

R. Barton Palmer, *Shot on Location: Postwar American Cinema and the Exploration of Real Places* (New Brunswick, NJ: Rutgers University Press, 2016).

John Alton, *Painting with Light* (Berkeley: University of California Press, 1995).

David Bordwell, *Figures Traced in Light: On Cinematic Staging* (Berkeley: University of California Press, 2005).

Louise Nevelson, Ad Reinhardt, and Richard Kostelanetz quoted in Wodek, *Black in Sculptural Art* (Brussels: Atelier 340, 1993), 193, 24.

Patrick Keating, *Hollywood Lighting from the Silent Era to Film Noir* (New York: Columbia University Press, 2010), 244.

Geoffrey O'Brien quoted in Copjec, ed., *Shades of Noir*, 59.

Hitchcock quoted in François Truffaut, *Hitchcock/Truffaut* (New York: Simon and Schuster, 1967), 131–2.

Gorham A. Kinden, "Hollywood's Conversion to Color: The Technological, Economic, and Aesthetic Factors," *Journal of the University Film Association* 31, no. 2 (spring 1979): 29–36.

Michael Chapman interviewed in Dennis Schaefer and Larry Salvato, *Masters of Light: Conversations with Contemporary Cinematographers* (Berkeley: University of California Press, 1984), 99–126.

Fredric Jameson, *Postmodernism: Or, the Cultural Logic of Late Capitalism* (Durham, NC: Duke University Press, 1991).

Christopher Butler, *Postmodernism: A Very Short Introduction* (New York: Oxford, 2002).

Richard Dyer, *Pastiche* (London: Routledge, 2007).

François Truffaut quoted in Peter Brunette, ed., *Shoot the Piano Player* (New Brunswick, NJ: Rutgers University Press, 1993), 5.

Jan Dawson, "Robert Altman Speaking," *Film Comment* (March–April 1974), 27–8.

Slavoj Žižek, "The Art of the Ridiculous Sublime: On David Lynch's *Lost Highway*," Walter Chapin Simpson Center for the Humanities, Occasional Papers no. 1 (Seattle: University of Washington, 2000).

Chapter 6: The afterlife of noir

Vivian Sobchack, "Chasing the Maltese Falcon: On the Fabrications of a Film Prop," *Journal of Visual Culture*, 6, no. 2 (2009), 219–46.

Thomas Elsaesser, "A German Ancestry to Film Noir? Film History and Its Imaginary," *Iris*, no. 20 (spring 1996), 129–43.

Foucault, Michel, *The Order of Things: An Archeology of the Human Sciences* (New York: Vintage Books, 1970).

Index

SOCIAL MEDIA
Very Short Introduction

Join our community

www.oup.com/vsi

- Join us online at the official Very Short Introductions **Facebook** page.
- Access the thoughts and musings of our authors with our online **blog**.
- Sign up for our monthly **e-newsletter** to receive information on all new titles publishing that month.
- Browse the full range of Very Short Introductions online.
- Read **extracts** from the Introductions for free.
- If you are a teacher or lecturer you can order inspection copies quickly and simply via our website.

AFRICAN HISTORY
A Very Short Introduction
John Parker & Richard Rathbone

Essential reading for anyone interested in the African continent and the diversity of human history, this *Very Short Introduction* looks at Africa's past and reflects on the changing ways it has been imagined and represented. Key themes in current thinking about Africa's history are illustrated with a range of fascinating historical examples, drawn from over 5 millennia across this vast continent.

'A very well informed and sharply stated historiography . . . should be in every historiography student's kitbag. A tour de force . . . it made me think a great deal.'

Terence Ranger,
The Bulletin of the School of Oriental and African Studies

FILM
A Very Short Introduction
Michael Wood

Film is considered by some to be the most dominant art form of the twentieth century. It is many things, but it has become above all a means of telling stories through images and sounds. The stories are often offered to us as quite false, frankly and beautifully fantastic, and they are sometimes insistently said to be true. But they are stories in both cases, and there are very few films, even in avant-garde art, that don't imply or quietly slip into narrative. This story element is important, and is closely connected with the simplest fact about moving pictures: they do move. In this *Very Short Introduction* Michael Wood provides a brief history and examination of the nature of the medium of film, considering its role and impact on society as well as its future in the digital age.

www.oup.com/vsi

FILM MUSIC
A Very Short Introduction
Kathryn Kalinak

This *Very Short Introduction* provides a lucid, accessible, and engaging overview of the subject of film music. Beginning with an analysis of the music from a well-known sequence in the film Reservoir Dogs, the book focuses on the most central issues in the practice of film music. Expert author Kay Kalinak takes readers behind the scenes to understand both the practical aspects of film music - what it is and how it is composed - and also the theories that have been developed to explain why film musicworks. This compact book not entertains with the fascinating stories of the composers and performers who have shaped film music across the globe but also gives readers a broad sense for the key questions in film music studies today.

'Kathryn Kalinak has emerged as one of the freshest and most authoritative commentary on film music of her generation.'

Michael Quinn, Classical Music

www.oup.com/vsi